Yeovil Memories

JACK WILLIAM SWEET

AMBERLEY

First published 2012

Amberley Publishing
The Hill, Stroud
Gloucestershire, GL5 4EP

www.amberley-books.com

British Library Cataloguing in Publication Data.
A catalogue record for this book is available from the British Library.

ISBN 978 1 4456 1061 0

Typeset in 10pt on 12pt Sabon.
Typesetting and Origination by Amberley Publishing.
Printed in the UK.

Contents

Introduction

n 2010 under the cover title of *Yeovil's Years*, I presented some of my articles which had appeared n the *Yeovil Times* from 1998 to 2005, and I grouped them into the twelve months of the year.

In this second book, I present some of the articles I wrote for both the *Yeovil Times* and the *Western Gazette* over the past thirteen or so years, and once again grouped them into the twelve months of the year. All of us have memories, some good, some bad and my selection of articles overs events in the town and neighbourhood that were good, not so good and a few downright ad – hence the title *Yeovil Memories*.

I hope you will enjoy looking back with me to these memories of my home town; they were a leasure to research, write and remember.

Jack Sweet, 2012

ecording happy memories of a holiday beside the a at Blue Anchor with my parents in August 1943.

Acknowledgements

My great appreciation and thanks to Lynne Fernquest, the editor of the *Western Gazette*, for permission to use the articles in this book.

A very special thank you to my wife Margaret, who during the years I wrote for the *Yeovil Times* and *Western Gazette*, and undertook my other literary adventures, has shown such great patience and tolerance.

Every effort has been made to contact the copyright holders. Please contact the publisher if you are aware of any omissions, which will be rectified in an future aditions.

Snow on Ilchester Road, 1912.

January

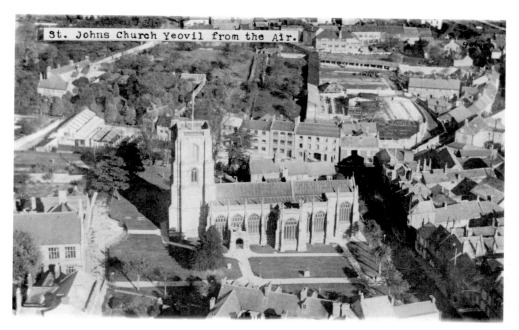

St John the Baptist Church in 1924.

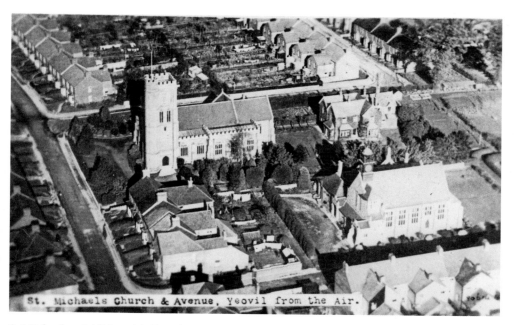

St Michael and All Angels' Church in 1927.

January, 1904

One hundred years ago, if you left your job without giving the required notice, you could find yourself up before the magistrates. On 5 January 1904, the Yeovil Borough Council, who ran the town gasworks, summoned one of its former labourers for leaving their employment without giving the necessary one week's notice. The man pleaded not guilty and the gasworks manager told the Bench that the labourer had 'been employed as a weekly servant and had been given a card with the terms of his employment printed on it, and, the terms were also pasted on the wall of the men's cabin'. The manager explained that the man had not come into work on a recent Sunday, claiming he had been ill, but enquiries had found that he had been drinking in a public house. He had cautioned the labourer, who did not, however, come into work on the following Friday. It was understood that the man had left his job at the gasworks, but without notice. The manager told the Bench that it was a serious matter for an employee not to come into work as the men worked in twos and threes and if two or three stayed away, the town's gas supply could be imperilled. The defendant pleaded that he had not known his terms of employment, but the magistrates ordered him to pay two shillings and sixpence damages to the Borough Council.

Four hundred 'old folks' were entertained in the Town Hall, shown here dressed up for the Coronation of King Edward VII in 1902.

On a lighter note, New Year 1904 was welcomed by the 'most successful long night dance of the season', in the Princes Street Assembly Rooms when over 170 danced through the night to 5 o'clock on New Year's morning. Mr A. J. Milborne's Quadrille Band provided the music and Mr Pitcher of the Mermaid Hotel provided the refreshments. Pupils of Messrs C. Wakely and F. Hooper's dancing class held their long night dance in the Masonic Hall on 4 January, to the popular Quadrille Band of Mr A. J. Milborne.

The 25th annual tea and entertainment for the 'old folks' of Yeovil was held on 5 January at 4.15 p.m. when over 400 'old folks' assembled in the Town Hall. During the interval between the tea and the evening's entertainment, 'selections of music were played by the Volunteer Band to which many of the fine old folks, despite that many had passed or were approaching the allotted span of three score years and ten, indulged in dancing.' The entertainment included songs, both serious and comic, musical selections, recitations, and the Yeovil Pierrots 'whose efforts to amuse the audience were eminently successful'. The evening concluded with the singing of the National Anthem, and on departure each of the 'old folks' received an orange and a two ounce packet of tea.

The Mayor and Mayoress, Mr and Mrs W. W Johnson, held an 'at home' for about thirty children in the Town Hall during the afternoon of 6 January. There were games, a magic lantern show and following refreshments, and the youngsters went home. In the evening the civic couple entertained 100 young people with a buffet meal and games and dancing to Mr Ring's orchestral band.

Accidents Do Happen

During the evening of 5 November 1900, Mr John Wallis of Newtown was in front of his house setting off fireworks and firing an old gun he used for scaring birds. He was holding a tin of gunpowder, which suddenly exploded, badly injuring his right thumb, and slightly burning his hands and face. Mr Wallis was taken to Dr Colmer's surgery in South Street where the thumb was amputated.

On Monday 2 June 1902, eighty-year-old Mr W. Cox and his wife were out for a stroll, but as the couple passed Mr Bradford's house at the bottom of Hendford Hill, a young lad called Lucas lost control of the bicycle he was riding down the hill and ran into Mr Cox, who was thrown heavily to the ground and temporarily stunned. Several passersby rushed to his aid, and Mr Cox was carried into Mr Maidment's nearby shop and then to his home. Although badly shaken, no bones were broken, but it was reported that he would suffer shock for some time.

The beginning of 1891 was very cold with plenty of snow and ice and, in the edition of the *Western Gazette* on 16 January 1891, a young lad called Dodge, living in Park Street, was tobogganing down Constitution Hill when he fell off his sledge and was knocked out. He was taken home and, after several days, was reported to be making a full recovery. Mrs King slipped on the ice in front of her house in Rustywell and broke her right arm. Mr Frank Hayward of Queen Street, who working as a porter at Hendford Station, also slipped on the ice and broke his arm in two places; the injured limb was set at Yeovil Hospital by Dr Aldridge.

On 18 September 1914, old met new at the junction of the Larkhill and Preston roads, when the car driven by Mr Marsh collided with Farmer Locock's horse and trap. Neither driver was

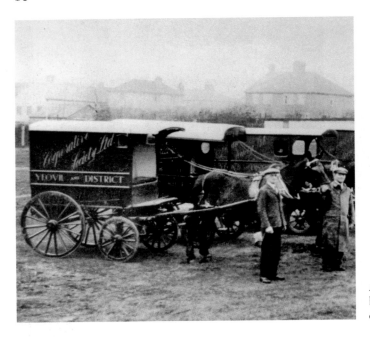

A Yeovil Co-operative Society bread delivery van similar to the one which crashed in Goldcroft.

hurt, but the car's radiator was smashed, its front lamps damaged, and one of the shafts of the trap broken; the horse was unhurt.

In 1934 another horse and some children had a lucky escape. The *Western Gazette* reported on Friday 27 April that:

Children playing with a beach ball in Goldcroft at mid-day on Saturday, caused a horse attached to a baker's van to bolt down Goldcroft Hill and crash into some galvanised fencing outside the engineering works of Messrs F W Sibley at the junction of Goldcroft and Crofton Avenue. The children were playing near a van belonging to the Yeovil Co-operative Society, from which Mr C Gillard of Great Western Terrace, was delivering bread. The ball apparently bounced against the horse and caused it to dash down the hill, with the van swaying wildly, while the children quickly scattered. The horse narrowly missed three motor cars and on reaching the junction of Goldcroft and Crofton Avenue endeavoured to turn the corner. The weight of the van, however, carried the vehicle across the road, where it crashed into the fencing. Fortunately the horse escaped without injury. The undercarriage of the van was badly smashed.

Dick Whittington, 1954

On 15 January 1954, the *Western Gazette* reported:

A rollicking riot of home-made fun – that is the Wessex (Yeovil) Social and Sports Club's 7th annual pantomime "Dick Whittington" at the Princes Theatre. The fun was home-made because the script was written by two members of the cast, Doug Smith and Ken Dover, and it was in the best tradition of pantomime – earthy humour, combined with a touch of telling fantasy.

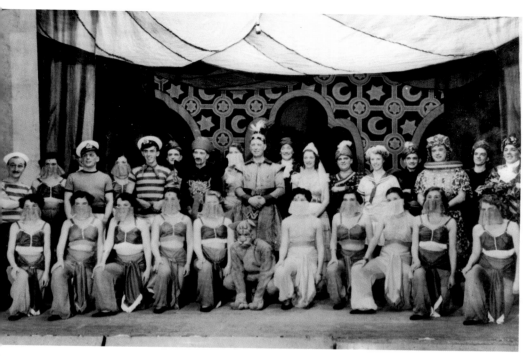

The cast of Dick Whittington on stage at the Princes Theatre.

The show owed its success to the infectious boisterousness of a buxom chorus and knock-about comics, the gay and imaginative costumes, and the brightly painted scenery, which provided a most effective back cloth to the antics on the stage.

Producer W.R. Consitt and director C.W. Austin kept everything running smoothly. Scene followed scene without those seemingly interminable waits for scenery changes. They made full use of the apron stage which helped to keep the production slick.

The club has a valuable asset in Valerie Stead. Not only did Valerie do some very graceful cavorting on the stage herself, but as choreographer directed the the chorus, a comely bunch of lasses – and lads – in some vigorous and skillful dancing. It was a pity, however, that more could not be seen of the top-hatted tap dancers, whose act during scene changes was one of the highlights of the show.

With Don Spinner to play Dame (in this case Cook), the producer was assured that every ounce of comedy, particularly the slap-stick variety, would be extracted from the script. Don Spinner, notwithstanding a heavy cold, did not let the producer down on Wednesday. Although slow to warm up he gave a fine performance.

Those decorative principals, Dolores Carter as Dick Whittington and Eileen Matthews as Alice the Principal Girl, gave the essential "olde-worlde" decorum to the production. Their singing and dancing was excellent, and Dolores Carter showed an excellent sense of stage-craft.

A bouquet to Noel Gulliver (Idle Jack) for a very amusing performance. His facial expressions, actions and gestures showed that sense of timing which stamped his performance as not the first in pantomime or at least on the stage. One criticism, however. Acoustics at the Princes Theatre

are not all they might be, and it was a mistake to face backstage when he sang the amusing ditty "I don't want a ricochet romance." In the later scenes he was well supported by Maureen Mullany as the man-chasing Princess Fatima.

Mike Budden and Syd Amatt, the knock-about sailors, had some of the best script, and they certainly made the most of it. Syd Amatt's india-rubber body bounced about the stage to great effect, and Mike Budden's facial contortions were very funny.

As the Cat, Graham Score's feline capers were most effective. His "fight to the death" with the terrifying King Rate (Doug Smith) was especially well done. Jim Cowan as Emperor of Morocco and Bert Hill as Grand Vizier, adequately filled their parts.

The troupe of sailors, Moroccans, singers, costers, slaves and dancers comprised Doreen Campbell, Heather Collins, Avril Cook, Cliff Dover, Dennis Dover, Ken Dover, Jeff Failes, Rona Hamilton, Audrey Hawes, Geoff Hayward, Myrtle Hodges, Dick Keetch, June Knight, Heather Lucas, Maurice Marks, Margaret Savage, Judith Tregear, Marjorie Turner, Mary Watkins, Phyllis Wilmot.

Musical Director was Harry Lawson and business manager, R. J. Pilkington. Behind the scenes were: Stage Manager, Rad Raymond; assistant Jimmy Rowe; lighting, Ross South; wardrobe mistress, Queenie Gay; property mistress, Peggy Budden; make-up Marion Young and Jim Hutton.

January, 1956

The New Year 1956 was welcomed in Yeovil by a crowd of some two hundred revellers - many of them members of the newly formed Yeovil and District Scottish Society, who had gathered in the Borough at midnight on that Saturday night half a century ago. Following traditional Scottish songs, the crowd joined hands, and as St John's Church clock struck midnight, sang 'Auld Land Syne'. The *Western Gazette* reported that the 'exiled Scots' continued their Hogmanay celebrations at many 'first footing' parties in the town.

Four days later, hopefully recovered from their Hogmanay celebrations, the Yeovil and District Scottish Society held its first general meeting at the Albion Inn in Vicarage Street. The local Society had been founded in the previous September by Miss K. Lavelle, Mr A. Monaghan and Mr J. Lawson, and now numbered about eighty members. The Secretary, Miss Lavelle, reviewing the past four months, said that between sixty and seventy members had attended the monthly meetings, a Scottish dance group had been formed, and a number of successful functions had been held, including a St Andrew's Night Dinner at West Coker and the Hogmanay Dance.

Returning home from a party in the early hours of New Year's Eve, Mr and Mrs H. Higdon noticed smoke and flames coming from the roof of Hendford Manor, and telephoned the Fire Brigade. Within minutes, the first of five appliances was on the scene to find flames shooting up to 50 feet from the roof and the smoke so dense that breathing apparatus had to be worn. However, the fire was successfully isolated from the main part of the building and was brought under control within half an hour. Hendford Manor was owned by the Yeovil Borough Council and contained the local office of the National Assistance Board, which was severely damaged and many of the 4,000 record cards lost.

A night of heavy rain caused the Hendford Brook to overflow. The flood, estimated to be 6 to 7 feet deep, swirled along Mill Lane, trapping Mr John Gundry in his house at 3 Mill Lane

A quiet High Street on a Sunday afternoon in the mid-1950s.

and inside lapped over the fourth step of his staircase. Following Mr Gundry's rescue by the Fire Brigade from his bedroom window, he told the *Western Gazette* reporter 'it was the worst flooding he had experienced during the 47 years he had been living in Mill Lane'.

In January 1956, the Somerset Standing Joint Committee, which administered the Somerset Police, adopted the recommendation of the chief constable to introduce the first police dogs into the county, the initial cost of which, would include buying two Alsatian puppies for about £40, providing kennels and training the dogs and handlers. The chief constable, in his recommendation pointed out that 'police dogs, besides being of considerable value in detecting crimes, could also be employed for many purpose such as finding lost children'.

February

The 1st Yeovil Company, The Boys' Brigade, photographed on the steps of the South Street Baptist Church *c*. 1944.

Yeovil School Football Team 1927/28 - Captain P. H. J. Harvey.

February, 1860

On Wednesday morning, 8 February 1860, there was great rejoicing in Yeovil – the Parish Church of St John Baptist, closed since February 1859, was re-opened following 12 months' extensive repair and refurbishment. The church bells rang out across the town, and shortly before 11 o'clock, the Lord Bishop of the Diocese, the Right Honourable and Right Revd Lord Auckland, was welcomed by the Mayor, Mr R. Tucker, in the town hall crowded with clergy and local dignitaries who then proceeded in the rain across the Borough to the church for the special morning service. The *Western Flying Post* reported that admission to St John's was by ticket only and 'the wisdom of this arrangement was manifested by the quiet and order which prevailed during the whole of the service'.

The works of renovation were extensive and included the removal of 'the unsightly galleries which crowded the whole of the internal space from west to east', new pews, furniture and screens, replacement of windows and stained glass, floor repairs and re-tiling, and restoring the roof beams and bosses.

The congregation packed the church again for the 6 o'clock Wednesday evening service, and the *Western Flying Post* reported:

An unusual view of St John's Church looking through the north door.

The events of the day seemed to form a matter of deep and earnest feeling of congratulation to all. Upwards of 1800 persons must have been present during the day. Superintendent Smith and his effective police kept the gates of the churchyard so that most perfect order reigned outside as well as inside the church. Flags were displayed upon the church tower, the town hall and the buildings, and the bells rang many merry peals throughout the day.

Parking was a problem in 1860 as it is today. Mrs Melina Rendall, a pastry cook, was summoned for leaving her cart in the street and causing an obstruction, and Job Milverton was fined ten shillings for leaving a horse and cart in the road opposite the Railway Hotel from a quarter to until a quarter past eleven on the night of 11 January. The Bench was told that Job Milverton had been convicted of a similar offence the previous month.

In 1860 all roads into Yeovil were controlled by toll gates charging for entry and exit with certain vehicles, goods and animals. Ann Gillard, hit upon a scheme to avoid paying tolls when she came to town to buy some goods; at least she thought she had! Ann left her horse and cart with a young lad in charge, a little way outside the tollgate at Kingston, and walked into the town. On her return through the gate with several large parcels she was requested to pay the appropriate toll but refused and was summoned to appear before the Bench. In court, Ann Gillard said that she felt her action to be justified, but was fined ten shillings and costs.

In conclusion and looking farther afield, in 1860 the self-adhesive envelope was designed by Jeremiah Smith, a British publisher, and John Newman invented the press-stud fastener as an alternative to buttons. The Open, formally The Open Championship of the British Isles, the first of the modern golf 'Majors', was established.

A Test Pilot's Life

Mr Harald Penrose will be remembered as one of Westland's great test pilots and in February 1940 he gave a talk to the Yeovil Rotary Club on the many and complex problems of test flying new aircraft. The *Western Gazette* wrote that Mr Penrose explained:

Although all conventional aeroplanes, of whatever size and speed, were controlled and flew in a generally similar manner, the precise behaviour differed widely from machine to machine, and one of the jobs of the test pilot was to ensure that the particular behaviour of a new plane did not differ greatly from what experience had shown to be acceptable. If there was a big difference, its operational value would be reduced because the pilot would have to concentrate too much on pilotage. The test pilot was not merely calibrating one aeroplane against another, but against his own reactions and physical powers, tempered by his judgement of specification requirements and constructional difficulties. The essential purpose of the test pilot was to ensure that the plane he tests, whether it was a new but standard machine from the production line, or an entirely untried new design, was safe for the pilot who would later operate it. After repeated tests and adjustments which might have occupied anything from three months to a year or more, the characteristics of the plane were known, its faults eliminated, and its controls and performance perfected so that one knew it to be a worthy weapon to hand over pilots of the RAF, or, in better times, one that would strike new trails of commerce through the skies.

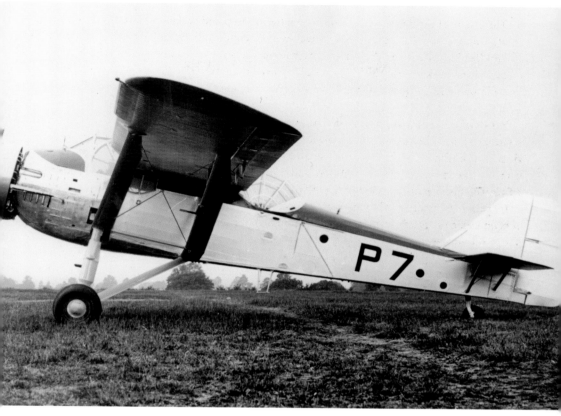

e Westland PV 7 from which Harald Penrose parachuted to safety.

veral years earlier, in August 1934, Mr Penrose was test flying a Westland PV 7 over Martlesham, e RAF experimental station near Ipswich, when the aircraft went out of control and began to eak up. The *Western Gazette* reporter, who later interviewed the chief test pilot, wrote that Mr nrose said:

I cannot remember much about it as it all happened very quickly. I have no recollection at all of jumping from the machine and the first thing I remember was pulling the cord (the release apparatus which automatically releases the parachute from its container) and floating gently down with the parachute holding me up. It took me about ten to fifteen minutes to come down and I landed in the middle of a field of stubble.

r Penrose added that the parachute he was using at the time was also used by an RAF pilot at artlesham about six months ago when he was forced to make an escape from an aeroplane in is way. As a result of this startling experience Mr Penrose automatically becomes a member one of the most exclusive clubs in the world, known as the 'Caterpillar Club'. Membership this strange club is only gained by those who have saved their own lives by jumping from an roplane out of control, and one of the most famous members of this organisation is Colonel

Lindberg, the famous American pilot, who was the first man to make a solo flight across th
Atlantic, and who, incidentally, has had his life saved four times by the 'life belt of the air
Members of the Club wear a gold brooch in the form of a caterpillar.

A Destructive Fire

It was one of those mistakes any one could make, the consequences were catastrophic, bu
thankfully no one was hurt. Just after 7 o'clock on Friday evening, 23 February 1906, or
of the shop assistants at Messrs Clements grocery shop in the High Street (the largest in Yeovil a
the time and the Argos store now stands on the site), went into the back cheese store taking wit
him a lighted candle. No doubt he was busy and probably preoccupied, and he went out leavir
the candle still alight. On returning to recover the candle, the assistant was horrified to find th
storeroom ablaze. Despite frantic efforts by the shop staff to extinguish the fire, it quickly gre
out of control and the Yeovil Volunteer Fire Brigade was called.

Led by Captain Edmund Damon, the Brigade 'responded smartly' and soon hoses wei
connected to three nearby hydrants, one in High Street with the hose taken through the sho
and the other two in South Street. By now the fire threatened the adjoining Three Choughs Hot
and two 'ancient' thatched cottages facing South Street. Although the Brigade contained the fi
on the hotel side and from the main shop premises, the flames could not be prevented fro
setting fire to the thatched roofs of the cottages.

The cottages were occupied by the Parsons and Field families, who were quickly evacuated; th
five children of the Field family were being put to bed at the time the fire broke out.

The thatch was over 2 feet thick and the volume of water poured over the roofs raised den
clouds of smoke lit by the lurid glow of the flames. Two firemen had clambered onto the thatc
but then had to retreat quickly when the roof began to fall in, and a family cat, rudely awakene
by the disturbance, was seen to jump out of one of the chimneys!

By late evening, the fire had been brought under control, but several members of the Briga
remained on the scene all night damping down the ruins.

The fire was sensationally reported in a London Sunday newspaper which caused the *Weste*
Gazette to comment:

> A sensational and totally unfounded report of the fire appeared in a London Sunday paper. This
> was to the effect that the children of Mr. Field were alone in the house when the fire broke out,
> and were gallantly removed by two firemen, and had a narrow escape from suffocation. The
> facts are that the parents were at home and that seeing the house was full of smoke the children
> were got to a place of safety before the house caught fire, and certainly before the arrival of the
> Fire Brigade. The danger of suffocation only existed in the imagination of the correspondent of
> the Sunday Paper.

The cost of the fire to Messrs Clements was between £800 and £900, for which they we
insured, but the Parsons and Fields were not so fortunate, being completely uninsured. Howev
a fund was set up to help the two families, the first to subscribe with £10 were Messrs Clemer
followed by the Mayor and Mayoress (Dr and Mrs Hunt) with £1 1s each.

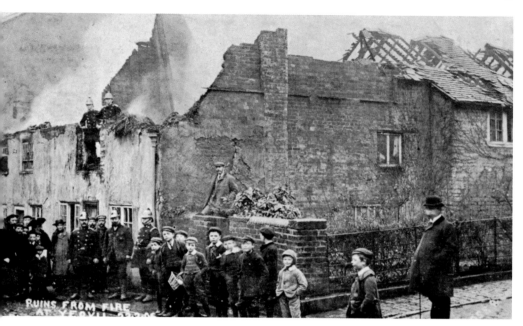

ae remains of the two cottages burnt out on South Street.

ebruary, 1890

ou know, the more I look back and read through the columns of newspapers of long ago, the ore it seems that many of the everyday problems, worries and exasperations of then are repeated w. Take for example the following letter to the Editor of the *Western Gazette* signed by a ominent Yeovil Dental Surgeon, Dr W. A. Hunt, of Pen Villa, and published at the beginning of bruary 1890:

Sir, – Many of our townsmen have long grumbled at the late delivery of letters, and especially of the first morning delivery; nor, have they complained without just cause. As a matter of fact the postal machinery has not grown *pari passu* with the increase of population. This could and should be rectified at headquarters. But I draw attention to another cause of delay. I undertook a short time ago to personally deliver a number of circulars, and I soon found out how many doors were without letter boxes and even knockers. Thus the bell might or might not ring at the first attempt, or if the bell sounded it was often minutes before I could get the "door answered." A very modest estimate would show a waste of an hour a day by each postman solely due to this cause. I would, therefore, suggest that every inhabited house, say down to a £20 or even £15 rental, should forthwith have a suitable letter-slit made in the front door, with a letter-box inside: this box could be inexpensively made of wire netting, which will catch the letters, and in which they will be visible even in a dimly lit passage.

House-owners could, at small expense do this; some, perhaps would be unwilling; but if new tenants on renting a house would demand such a post-box, this demand would in time quite counter-balance any little obstinate selfishness that a few owners might possibly exhibit.

The more punctual delivery of letters, with saving of friction to house servants on the one hand and the great saving of time and friction to the postman on the other, must be my excuse to writing to you at such length.

The Constitutional Club held a 'Cinderella Dance' in the Assembly Rooms and over a hundre members and friends danced to Mr Griffin's orchestra from 8 p.m. until midnight.

Looking back to those far off days, there can be great pleasure in reading about the local soci events enjoyed by Yeovilians of all ages at the time. Early in February 1890, the Christmas an New Year's celebrations had not quite come to an end. About 130 members of the Congregation Band of Hope held their annual New Year's treat in the schoolroom off Clarence Street – 'A lar; Christmas tree laden with useful articles and toys was provided and each child received a prese: from the tree. Various games were engaged in, and recitations were given at intervals by some the children.' The annual winter treat of the Yeovil Juvenile Templars, with Christmas tree ar games, was held in the Trinity schoolroom.

A Yeovil postman from the 1890s.

March

'The Banks' Hockey Team photographed on the sports field at West Hendford in March 1908.

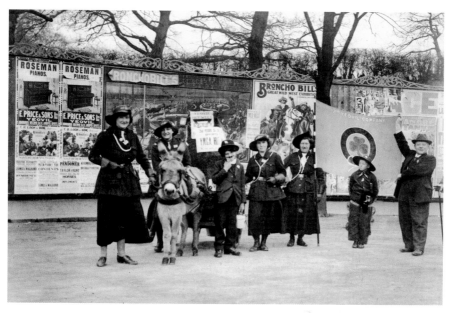

Members of the 2nd Yeovil Company Girl Guides and some supporters, with their barrel organ and donkey on the forecourt of Town Station, before they set out on a street collection for the YMCA Hut Appeal in the Spring of 1917.

March, 1870

Foot and Mouth Disease was as greatly feared in 1870 as it is today, but suspected outbreaks in herds at Ash, nearby Witcombe, and in the Ilchester area, proved to be unfounded, much to the relief of the farming community and the owners of Yeovil Market.

In 1870, local schools which received government grants towards teachers' salaries, were subject to inspection, and in March, the Reverend Tregarthen, one of Her Majesty's Inspectors reported on his visit to Huish Schools (now part of Tesco's store). Payment of the grant depended upon a favourable report, and to the relief of all concerned, the reverend gentleman reported that the 'Boys' School is in good order and exceedingly well taught'. The headmaster, Mr Edwin Maidment 'is a good teacher and the exceedingly satisfactory state in which I find his school does him great credit'. Regarding the Girls' School, this was found to be in a 'very fair state of efficiency', with the mistress, Miss Williams discharging her duties in a very satisfactory manner and Miss Maidment's Infants' School was being taught 'by a most energetic and earnest teacher'.

The next time you complain about the speed of your internet broadband or telephone connection, bear in mind this report in *Pulman's Weekly News* of 1 March 1870:

THE POST OFFICE TELEGRAPH farce is unabated. Last week a message sent from London at mid-day reached our office [in Yeovil] at 8.15 – thus occupying about the same time as it would take a train to come from London and go back again. A message from Chard to Crewkerne – eight miles – took nearly two hours – about the same time as a man might walk the distance.

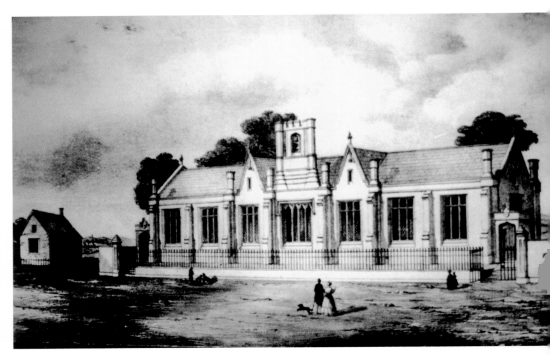

A favourable report was received from Her Majesty's Inspector on the teaching at Huish Schools.

The newspapers, which were almost unanimous in inviting the Government agency – the object, of course being the supposed curtailment of expenses – are now very loud in their complaints – as if centralisation and inefficiency were not identical.

The *Bristol Post* contains the following:

"The more one sees of the telegraph system, since its transfer to the hands of the Government, the less it is liked, and a strong opinion prevails that a great mistake has been made by Parliament in sanctioning such a change. From every quarter and every class come loud complaints. In Clifton, with a population exceeding 30,000, the Postmaster announces in his window that he will send messages only from nine till five, and on Sundays one hour from nine till ten. This will never do. We are not surprised to find that an effort is to be made in Parliament to break the Government monopoly by organising another company to serve the public as it was served before. At present no reliance can be placed on the prompt delivery of messages. Many have been obliged to discontinue the practice of telegraphing, owing to the uncertainty and delay which prevail."

etter's and Westlands

etter's oil engines manufactured in Yeovil were exported all over the world, and in the early ays of the company, the firm's engineers would travel far and wide setting them up or repairing em in the rare case of failure. One such engineer was Mr Herbert Swetman about whom the

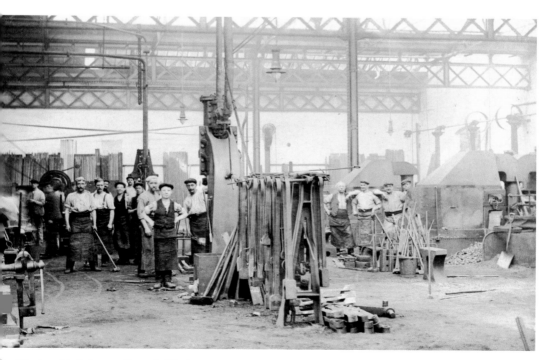

he Blacksmiths' shop at Petter's Works.

Western Gazette reported on 16 March 1906:

> Mr. Herbert Swetman, of Orchard Street, Yeovil, has just returned from Theodosia, South Russia, where he has been for the last two months erecting several large engines manufactured at the "Nautilus Works." Mr. Swetman has had many interesting experiences, having been some six or seven hundred miles north of Odessa in the heart of the country. He describes the country which he saw as being fine agricultural land, and with better systems of Government he has little doubt but that the country would prosper greatly. Mr. E. W. Petter, who went out with Mr. Swetman, parted from him at Odessa, having gone on to Constantinople, and from thence to Syria and Egypt, from where he hopes to return to England in May.

In July 1916, Mr Benjamin Jacobs was presented with an Illuminated Address and a £100 War Loan Bond by the Directors of Petters Ltd, in recognition of his twenty-one years service with the company, and for 'the valuable services rendered by him in connection with the design of the first Petter oil engine in 1895'. Mr Jacobs, an all-round engineer, draughtsman, pattern maker and machinist, had been appointed foreman in 1891 and without his skills it is possible that Petters might not have become one of the leading manufacturers of oil engines, and as a consequence there may well have been no Westland Aircraft, and Yeovil would be a very different town today.

In the early spring of 1945, with peace in Europe now a reality, the future of the Westland airfield was discussed by the Somerset County Council's Planning Committee and the *Western Gazette* reported on 30 March that:

> Consideration has been given to a letter from the Yeovil and District Chamber of Trade bringing to their attention a recommendation of the Bristol Chamber of Commerce concerning the establishment of an international aerodrome at Bristol, and, subject to the licensing of Westland aerodrome at Yeovil for civil aviation, a proposal that the Westland Aircraft Company Ltd., should operate a local taxi or feeder service, from that aerodrome, in which project they wished to solicit the interest of the County Council. They understood the County Works Committee had favourably considered the matter from a highway point of view.
>
> The siting of aerodromes was dealt with in the report of the Three Counties Conference of May 15th 1944, in which the provision for an aerodrome in the vicinity of Yeovil was recommended. They had informed the Yeovil and District Chamber of Trade and the Yeovil Joint Planning Committee that as the licensing of the Westland aerodrome for civil aviation on the lines proposed would be in the regional proposals dealing with aerodromes, they had no adverse criticisms to make in the matter.

Another interesting speculation on Yeovil's development – if a feeder or local airport had been developed on the airfield.

A New Motor Garage For Yeovil in 1931

For nearly 60 years, until it was demolished in 1990, the tower of Messrs Douglas Seaton's garage at the junction of Huish, Clarence Street and Westminster Street was a familiar Yeovil landmark.

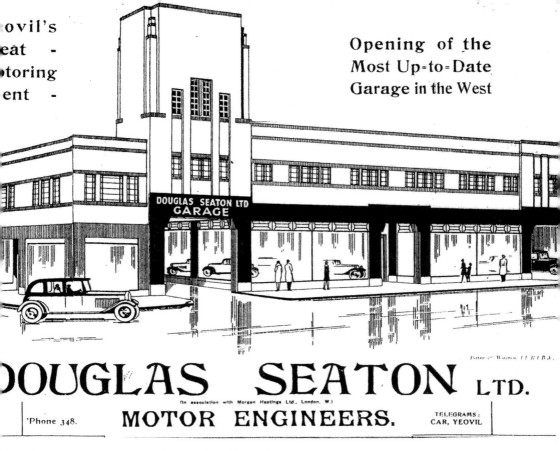

ovil's
eat -
toring
ent -

**Opening of the
Most Up=to=Date
Garage in the West**

DOUGLAS SEATON LTD GARAGE

Potter & Warren, LL R I B A

DOUGLAS SEATON LTD.
(in association with Morgan Hastings Ltd., London, W.)

'Phone 348. **MOTOR ENGINEERS.** TELEGRAMS:
CAR, YEOVIL

The advertisement announcing the opening of Douglas Seaton's new motor garage.

Now it is the site of Tesco's car park. On 27 March 1931 the *Western Gazette* announced that this was a 'NEW MOTOR GARAGE FOR YEOVIL' and went on to write that:

A striking addition to the many up to date business establishments that have been erected in Yeovil during the past few years was launched upon its career of service on Wednesday, when the Mayor of Yeovil opened in the presence of a representative gathering of the motoring public, the handsome new garage of Messrs Douglas Seaton Ltd in Westminster Street. On 100,000 square feet of land there has arisen in 12 months a building not only worthy of the town and the many fine buildings with which it so happily harmonises, but one, that is claimed, provides the "last word" in motoring facilities and needs. With its tower, spacious showrooms, car park, and petrol filling station, the exterior view of the new garage provides a notable example of enterprise, and at night, under flood lighting, is an impressive sight. Still more striking is the interior and all its equipment and facilities.

The new building is in the heart of the town and within sight of the Town Hall. The main garage has three entrances and exits, the principal one being opposite Westminster Street, thus providing a straight drive in from the centre of the town. A spacious showroom, with marble facings, oak floor and enriched ceiling, provides accommodation for 30 large cars. The general garage provides accommodation for no fewer than 150 cars. It is constructed of steel

throughout, with concrete floor and brick walls, and the roof is fire proof. A notable feature is the total absence of pillars or upright girders, the whole floor area being left unobstructed. There are seven private "lock-ups" capable of taking the largest cars, and these share the heating system, which consists of hot water radiators worked from an automatically controlled oil-fired furnace, which keeps the whole building at a pre-determined temperature. The architecture was carried out by Messrs Petter & Warren and the main contract for the building was placed with Messrs Bird & Pippard; the electrical wiring with the Electric Light and Power Company; and the installation of machinery with Mr Fred Dibble.

Prior to the formal opening of the new building, about 180 representative residents of the town and district were entertained to luncheon in the town hall by Messrs Douglas Seaton Ltd. Sir Ernest Petter had been invited to perform the opening ceremony, but due to his absence through an indisposition, the Mayor took his place. Speaking at the luncheon, Mr Percival Petter, Sir Ernest's twin brother, stated that the new establishment had a great personal interest for him because it was built on the site of the works in which he had started his business life 42 years ago. On this site, also, Petters had built the first internal combustion engine motor car in this country.

March, 1920

The First World War had been over nearly sixteen months, and members of the armed force were still being invested with medals for gallantry awarded during the conflict. Captain E. J. Boon, formerly of the Royal Garrison Artillery, and now with the Yeovil firm of Messrs Taylor and Hunt, received the Military Cross from King George V at an investiture at Buckingham Palace. The citation read – 'During a bombardment a shell hit a dump of shells, exploding some and setting fire to a number of cartridges. At great personal risk and under fire the whole time h succeeded in extinguishing the fire before it spread to a pile of fuse shells.'

In the first week of March 1920 Albany Ward's Palace Cinema in the Triangle was showing a full programme of films. On Monday, Tuesday and Wednesday, Sessue Hayakawa starred in *His Birthright* – 'An Intense Drama' followed by *A Self Made Hero* described as a 'Fine Comedy' and *His Quaker Girl* advertised as 'A Scream', all accompanied by Episode 10 of the serial *Elmo the Mighty*. Thursday, Friday and Saturday (no Sunday shows) offered *For Freedom* – 'A Fox Big Drama' with William Farnum – and 'Your old favourite Charlie Chaplin' in *The Floor Walker* said to be 'A Yell' completed the programme. In addition to the films there was a live performance in the 'Return visit at Enormous Expense of Miss Adelaide Gretton the renowned Contralto direct from Covent Garden successes.' There was also the 'Special Engagement of Moore Bros, Unique Dancers.' Musical accompaniment was provided by W. Ring's Orchestra directed by Mons. A. V. Paquay.

However, if you were a child under 15 years of age you were banned from the Palace Cinema due to an outbreak of measles in the town. By the first week of March, seventy-three cases had been confirmed amongst school children, and Huish Infants and Junior Schools were closed for two weeks. The Medical Officer of Health stated that the disease had been brought into Yeovil by children attending private schools outside the town where measles had broken out some week before.

Runaway horses were a hazard eighty one years ago. A horse and wagon belonging to Messrs Chaplin & Co was being driven along St Michael's Road when the horse suddenly bolted. Th

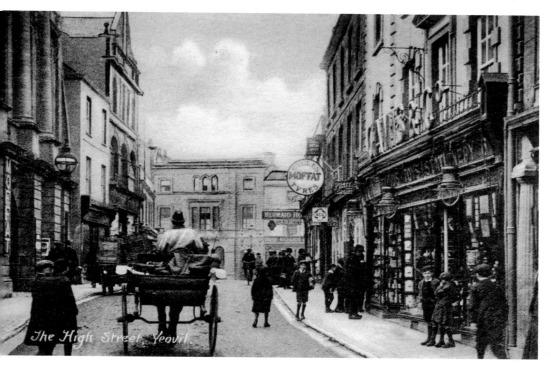

lone horse and trap proceeds along High Street in the early 1920s.

eins broke and the driver seeing that there was no way he could stop the runaway jumped out.
he horse galloped to the top of Victoria Road and came to a sudden halt as it tried to get down
rough a narrow passage way between a house occupied by Mr Dimond and a garden. One of
e shafts went though the wall into Mr Dimond's sitting room, and the horse was thrown down
etween the fence and the wall of the house. Sadly the horse was very badly injured and died.

In the winter of 1920 there was an acute shortage of houses to buy or rent, and the following
dvertisement in the *Western Gazette* was one firm's attempt to help the situation:

A DWELLING MADE OF TIMBER – The Army Hut is therefore taking the place of the
unobtainable brick or stone built house. A fine type of this kind of House - built on a strong
wood frame, the exterior walls of weather boards and the interior of 3-ply wood with a strong
floor, 1 inch thick, roof covered with felt, size 60ft. long, 15ft wide, 10ft high to ridge, with stove
included –
PRICE £125
IS SUPPLIED BY HARRY HEBDITCH MARTOCK, SOMERSET.

April

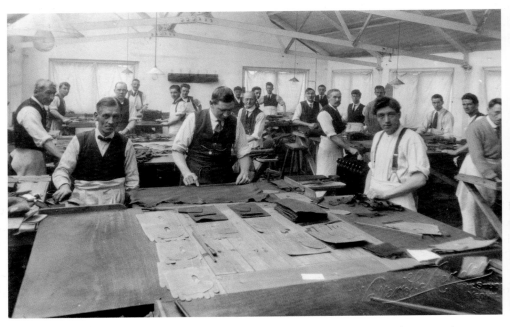

The glove cutting shop of Messrs Atherton & Clothier's leather glove manufacturers' factory on Court Ash.

Staff of Messrs Clothier & Giles, leather glove manufacturers, waiting at Sidney Gardens to leave on their annual outing.

April, 1907

Easter 1907 was early, and on Easter Monday over 200 excursionists left by rail for Weymouth and another 246 travelled to the Wincanton races. However, Good Friday was not the best of days for Mrs Garlick of the Elephant & Castle Hotel whose brake failed as she cycled home from Stoford down Newton Road. The *Western Gazette* takes up the story:

> In descending the steep hill near Newton Farm the brake failed to act, and whilst going at high speed a crowd of children were encountered at the foot of the hill. In turning the machine to avoid what might have been a serious accident to one or more of the infants, the railings were collided with, and the rider thrown violently into the road. Mrs. Garlick sustained a severe shaking, and was much bruised, and her clothing was entirely spoilt by tar from the railings. On examination of the machine it was found that the screw from brake rod was missing. Hence the failure of the brake to act.

The town magistrates were busy during the early days of April 1907. A 'pedlar' from Bournemouth with the wonderful name of Dangerfield Barney, was fined two shillings and six pence for being drunk and disorderly, and Thomas Burchell from Preston in Lancashire, and Thomas Clarke of Chartham were fined five shillings each for being intoxicated in Park Street.

Percy Stone, Sidney Davey and Percy Spear, 'boys of Newtown', pleaded guilty to playing football in Eastland Road to 'the annoyance of foot passengers'. William Peaty, described as an

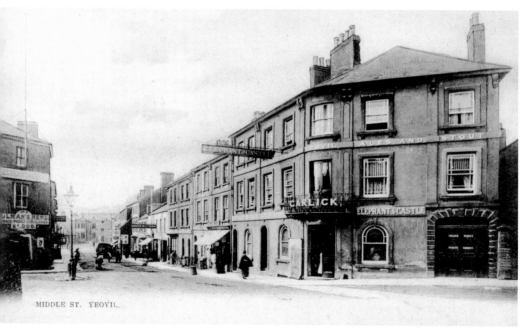

MIDDLE ST. YEOVIL.

Mrs Garlick crashed her bicycle in Newton Road on her way home to the Elephant & Castle.

'elderly man', told the Bench that he had fallen and injured his shoulder when a football kicked by one of the boys passed between his legs. The youngsters were each fined two shillings and six pence, and received a lecture from the Mayor, the Chairman of the Bench, and told not to play football in the streets, but to go to Wyndham Field to play.

There were changes in Yeovil Police – PC Morgan was transferred to Bishops Lydeard and promoted Sergeant, and replaced in Yeovil by PC Matravers from Wrington.

Miss Lilian Lawes gave a concert in the Princes Street Assembly Rooms on Wednesday evening 3 April, attended by:

A critical, though appreciative audience, who gave the rising young vocalist a very hearty reception at what was practically her first public appearance, and who thoroughly enjoyed the first class and attractive programme she presented. Miss Lawes possesses an exceptionally clear soprano voice of good compass and her enunciation and control of it should assure her a successful future.

Accompanying Miss Laws were Miss Ethel Marsh (violin), Mrs H. S. Bullock (piano), Miss Hugolin Haweis (reciter) and baritone Mr H. Lane Wilson, whose rendering of 'Glorious Devon' stirred the audience to 'unstinted applause and demands for recall'.

HMS *Yeovil*

As the First World War raged from 1914 to 18, one of the most dangerous threats to Britain's survival came from the interruption of our supplies of food and fuel by German submarines and mines. Mines in many respects were the most deadly, and compared with the cost of a submarine were cheap and could be produced in thousands. They were laid in great numbers in the shipping lanes and near ports and harbours where they floated just below the surface of the water awaiting a ship to strike one of their soft metal horns and detonate the explosive charge. Nearly 600 British warships, merchant ships and fishing vessels were lost to mines between 1914 and 1918.

To deal with this menace, the Royal Navy at first adapted fishing trawlers as minesweepers and later purpose-built vessels entered service. The ships usually worked in pairs, linked by a serrated wire which cut through the mine's mooring cable, and when the mine bobbed to the surface it was sunk or exploded by rifle fire. Sometimes the cutting was carried out by a single ship, but whether alone or in company, minesweeping was a very dangerous task; two hundred and fourteen minesweepers were sunk or damaged.

One type of purpose-built minesweeper was the 231 feet long, 800 tons Aberdare class, armed with one 4 inch and one 12 pounder gun with a complement of 74 officers and ratings. The Aberdares, named after inland towns, were a successful design and some lived on to see action in World War Two. One of the Aberdares was HMS *Yeovil*, built on the Clyde and launched on 27 August 1918. *Yeovil* commenced the dangerous task of minesweeping off the West Coast of Scotland on 16 November 1918, five days after the Armistice brought the war to an end, and where she would operate for the next five months.

In April 1919, HMS *Yeovil* departed the West Coast of Scotland and steamed across the North Sea to the Norwegian port of Lervick, south of Bergen. The Germans were not the only nation who used mines against their opponents' shipping, all the belligerents laid them. Back in 1918

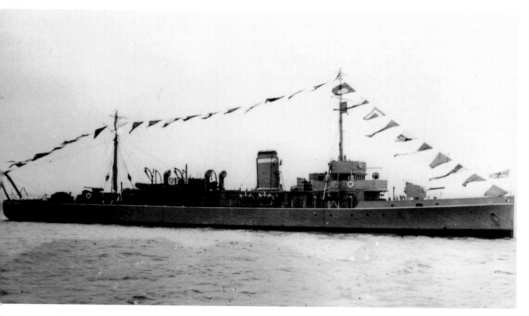

HMS *Yeovil* helped sweep the seas clear of mines following the end of the First World War.

Between May and November, American and British warships had planted over 70,000 mines between the Shetlands and Norway, mainly to catch surfaced or submerged U-boats. With the war over these had to be cleared, and one of the ships charged with that task was *Yeovil*. This was hard and dangerous work, with five days at sea and three-day interludes at Lervik. For most of the time, *Yeovil* was partnered with HMS *Belvoir,* and in May 1919 the two ships swept 1710 mines between them, 175 exploding in the sweep wire close enough to bodily lift the ships.

Public Eye

The following notice was given in Yeovil on 31 May 1870:

BOROUGH OF YEOVIL – PUBLIC NOTICE
USE OF BICYCLES
NOTICE is hereby given that at a meeting of the Council of the said Borough duly holden at the Town Hall on the 30th day of May it was ordered that no bicycles be used in any street, road or highway within the said Borough and notice is hereby given that any person using any bicycle contrary to the foregoing order will be prosecuted according to law.
Dated this 31st day of May 1870
James Curtis, Mayor

Day Out

At the April 1891 meeting of the Yeovil Board of Poor Law Guardians a suggestion by the Workhouse Master that the aged and infirm inmates should be allowed to go out of

The windows of Hill & Boll's showrooms, shown on the right of the picture, were damaged by careless demolition team.

the Workhouse on a specified day each month was referred to the House Committee for investigation. (The suggestion was subsequently approved).

Street Names

The Improvement Committee's recommendation to the Borough Council on 10 April 1893 to adopt the line of two new roads from Huish to West Hendford was adopted. The Committee Chairman stated that the roads would be called 'Beer Street' and 'Orchard Street' to which one wit remarked that the latter should be changed to 'Cider Street'.

The Boy Jeans Again

At the monthly meeting of the Yeovil Board of Poor Law Guardians in October 1895, the master reported that two brothers named Sidney and John Jeans had played truant from school. They had walked to their home at Martock and were brought back by their sister. The Chairman, Mr C. Trask, enquired whether this 'was our old friend, John Jeans' and the master confirmed that it was. No further complaints had been received about the boy's conduct at school. The master stated that as punishment for the offence John Jeans had been kept in bed for two days, but added that the boy seemed to like such treatment.

What No Convenience?

The Improvement Committee reported to the Borough Council in December 1912 on the use of the old fire station in Vicarage Street as a public lavatory. The Committee recommended against

ch use on account of the cost and suggested that the building should be let. Alderman Boll
otested as he strongly believed there was a need for a ladies public lavatory in the town and
proposed an amendment that the premises be let with the exception of a small corner at the
trance to Silver Street, which could be reserved for a 'Ladies.'

Councillor Higdon considered that this would be a waste of public money and the site was
suitable. If the Council wanted to provide such a place there was the ideal spot near the spare
all by the Gas Works.

After further discussion Alderman Boll's amendment was defeated, the recommendation of the
provement Committee adopted, and the old fire station was placed on the market for letting.

ang!

he Borough Council was in for a shock at the meeting in July 1922 when a bill for £32 10s
1 was presented for providing and fixing two plate glass windows for Messrs Hill & Boll's
owrooms in Princes Street. The windows had been smashed when some Council workmen blew
the roots of a nearby tree without taking the necessary precautions to prevent blast damage.
ouncillors were more than annoyed to find out that the man in charge of the demolition team
d ignored advice on appropriate precautions.

pril, 1965

he following article appeared on the back page of the *Western Gazette* of 30 April 1965:

LEADING POP GROUPS COMING TO YEOVIL

Britain's leading rhythm and blues group, the Rolling Stones will be coming to Yeovil later this
year and other famous groups who will visit the town are the Barron Knights, Freddie and the
Dreamers, and Gerry and the Pacemakers. This was stated by Mr. Richard Cooper, the 19-year-
old chief of Eagle Entertainments Ltd., the company who stage dances at the Yeovil Liberal Hall
and who have already brought such popular groups as The Animals, Herman's Hermits and
Billy J. Kramer and the Dakotas. During May star Thursday attractions will be Wayne Fontana
and the Mindbenders and the Hollies. The latter group should have visited Yeovil earlier this
year, but had to call off owing to illness. In addition to Thursdays, the company will now stage
fortnightly Tuesday pop shows to alternate with wrestling. Groups booked appear are The
Honeycombs and Unit 4+2.

r Donald Long, of the Motor Shop in Wyndham Street, could not believe his eyes and was
nazed when a customer brought in a car radio for repair, because he had seen it somewhere
fore. In fact he had seen it in his own car from which the radio had been stolen only the
evious night whilst it was parked in a yard at Earle Street. A few weeks later on 30 April,
e *Western Gazette* reported that a young man had pleaded guilty in the magistrates' court to
ceiving the radio knowing it to have been stolen and fined £5. In his statement, the defendant
ated that he had thought it had been stolen, but had sold it for £2 to the person, who in all
nocence had taken the radio in for repair.

The Yeovil Borough Council's Highways Committee, at its April meeting agreed in principle
ban through-traffic in Middle Street. The new system (which was adopted), would close

Middle Street in 1965 when the new traffic scheme was introduced.

the entrance to Middle Street from the Borough, and route all traffic down Silver Street, alor
Vicarage Street to the Triangle, and Wine Street would be one-way to Union Street. Union Stre
would become one-way from South Street to Middle Street, when vehicles would turn le
towards the Borough or right down Middle Street. Bond Street would be one-way from Sou
Street to Middle Street, with only right turn at the junction down to the Triangle, and Peter Stre
would become one-way to Union Street. During the meeting the Borough Surveyor, Mr Arth
Heal, announced that a grant had been received for the construction of the Yeovil Inner Reli
Road dual carriageway across Bide's Garden to the Kingston/Princes Street junction.

The *Western Gazette* reported that on 25 April, the headquarters and sorting office of Yeov
Post Office had transferred from King George Street to the new building at Huish which wa
now the head post office, and the counter service at King George Street would continue as
branch office. The telephone exchange in Clarence Street would be transferred to Huish durin
the coming twelve months.

May

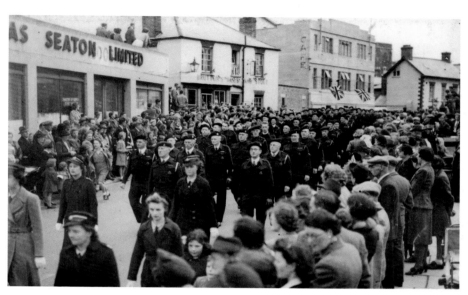

Civil Defence personnel passing Douglas Seaton's Garage as part of the procession of over a thousand men and women of the three fighting services, civil defence and the United States Army, on their way to the Public Thanksgiving Service at the Huish Football Ground on 9 May 1945 – VE Day plus one.

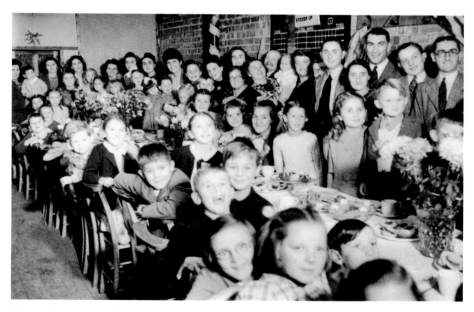

The Stiby Road children's VE Day party on 9 May 1945 in the skittle alley of the Westfield Hotel.

May, 1893

On Friday 5 May 1893, the *Western Gazette* reported:

A connection between West Hendford and Huish is being made by the construction of a road through the property of Mr W. T. Maynard. The road which is being drained and metalled, has been divided into two streets, to be styled "Beer-street" and "Orchard-street" and at the entrance to the first named, a villa is in course of erection for Mr. Levi Beer. There are altogether more than a hundred and twenty sites for artisans' dwellings on the property, which is very picturesquely situated and these will offered by public auction this (Friday) afternoon.

At the auction that afternoon in a large marquee: 'The increasing prosperity of the town wa strikingly evidenced when a most successful and important sale of a large number of buildir plots took place on the property of Mr. W. T. Maynard at West Hendford.' The land was divide into 107 plots and offered for sale in lots of two plots. The sale prices of the dual plots range from £55 to £160 for the corner site with a frontage to Huish and Orchard Street.

On 9 May, the 57th Battery of Field Artillery, rumbled into the town, *en route* from Ipswi to the Oakhampton ranges for firing practice. The ninety-nine men were billeted overnight various inns and the six guns were parked in the Borough; the battery's seventy-four horses we stabled around the town. During the evening, some of the gunners were entertained to tea in t Victoria Hall by the local branch of the Church of England Temperance Society – 'a plentif

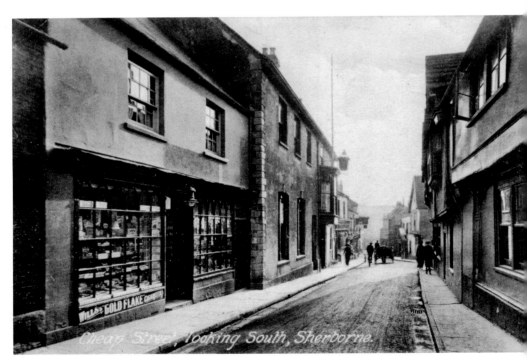

The Yeovil Men's Christian Association Cycling Club visited Sherborne on 1 May.

upply of pipes and tobacco was provided and cards and other games were played'. Tea was ollowed by an entertainment of songs to Miss Fudge's piano accompaniment.

The Monday evening run of the Yeovil Men's Christian Association Cycling Club on 1 May ook them to Yetminster and Sherborne, and the following week found the twenty members isiting Queen Camel. The 'Wheelers' Club's Thursday evening run took them to Tintinhull, Martock, and Montacute, and on the 11 May, the 'Wheelers' left their HQ in the Mermaid Hotel nd cycled to Milborne Port where they were entertained to refreshments by Sir E. B. Medlycott t Ven House. The Yeovil Cycling Club's Thursday outings were to Melbury and Crewkerne.

The town magistrates' court was busy during the first week of May 1893. A local builder was ned five shillings and costs for not obtaining a certificate from the Rural Sanitary Authority supply water for a new house in Lyde Lane. His plea that a proper source of water had been aid on but he had forgotten to obtain the certificate was not accepted. Drunks were much in vidence at the court on 2 May. Among those dealt with was a working man who, because of his ood character, was only fined two shillings and six pence for his intoxication. Another, when ned seven shillings and six pence, complained that the local police were like 'cats watching ice'. A young soldier found drunk and disorderly on Hendford Hill pleaded that if he was ned for the offence he would lose two pence a day from his pay for the next two years, and is being confirmed by Police Superintendent Self, the Bench ordered the soldier to pay only e costs.

The *Western Gazette* reported that Nurse Dowding, the Yeovil day and obstetrical nurse, had assed her examination for the diploma qualifying her as a midwife of The Obstetrical Society.

he Central Cinema Fire

 the early hours of Saturday 24 May 1930, fire broke out at the Central Cinema in Church treet. A Mr Curtis was taking a breath of fresh air from the Empire Day Celebration Dance the nearby Assembly Rooms in Princes Street, when he saw flames and smoke pouring from e cinema. After giving the alarm he was joined by Police Constable Udall, and together the vo men managed to get into the building where they found the proprietor, Mr A. S. Thring, emi-conscious in his blazing office, and carried him to safety. Mr Thring was suffering from nock, the effects of smoke and badly burnt hands and quickly conveyed to hospital. By the time e volunteers of the Yeovil Fire Brigade arrived on the scene, the cinema was well alight and ere was danger of the fire spreading out of control into adjoining premises. The dance in the ssembly Rooms was immediately concluded, and the dancers turned out into Princes Street to atch the action.

Four lines of fire hoses were laid through Church Street, and the battle began to contain the laze which was beginning to take hold of part of the adjoining St John's Schoolrooms.

Despite the flames being fanned by a strong wind, the brigade slowly recovered the initiative, d after four gruelling hours, finally quelled the blaze. Much of the Central Cinema was recked, but amazingly it was reported by the *Western Gazette* that the 'projecting box had caped, and an electric gramophone, recently installed at a cost of £200, was unharmed'. A uarter of the roof of the main hall of the St John's Schoolrooms had been destroyed, wreckage as strewn everywhere, and two ante-rooms were piled high with shattered roofing material; assrooms on the ground floor were also damaged by water.

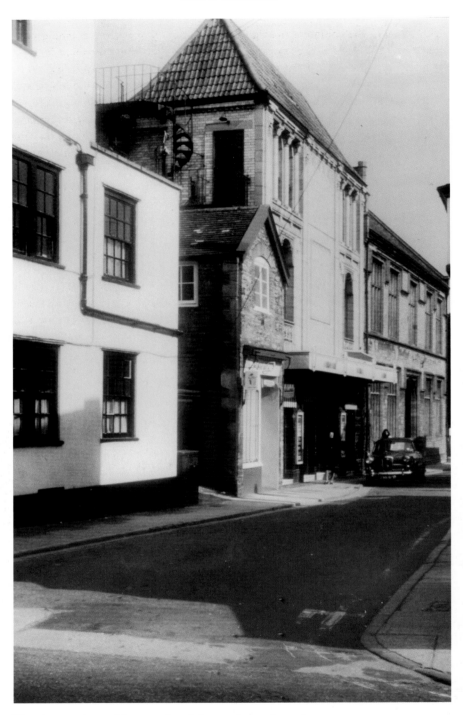

The cinema pictured here, replaced the one burnt down in 1930.

Although several of the volunteer fire fighters had lucky escapes from crashing roof timbers nd tiles, the only casualty was the proprietor, Mr Thring, but after treatment he was allowed ome later in the day. The cause of the fire does not seem to have been established.

In January 1932, the rebuilt Central Cinema opened for business, and at the time was described y the *Western Gazette* as 'Yet another example of the enterprise and development which have iven the town such a rapid modern trend. The striking appearance of the new building, which in the Persian style, vies with the comfort and elegance of the interior.' The new cinema with ating for 560 was designed by Exeter architect, Mr Douglas E. Langford, and boasted 'the last ord in comfort in an attractive oriental setting.'

The offices of solicitors Porter Dodson now stand on the site of the old Central Cinema.

mpire Day, 1909

)n Friday 28 May 1909, the *Western Gazette* wrote:

Yeovil's contribution to the world-wide observance of Empire Day were of a much more extensive and elaborate character than those of former years, and truly illustrated the enormous growth of this movement, first started in Canada in 1896 for the setting apart of a day as one on which the children should be taught rightly to appreciate what they owe to the British Empire, and to recount its history and glorious traditions. The date chosen, May 24th, is a fitting one. It is the birthday of the Great Queen Victoria, who did so much for the Empire, and in whose reign it progressed and solidified far more than in any previous reign in history.

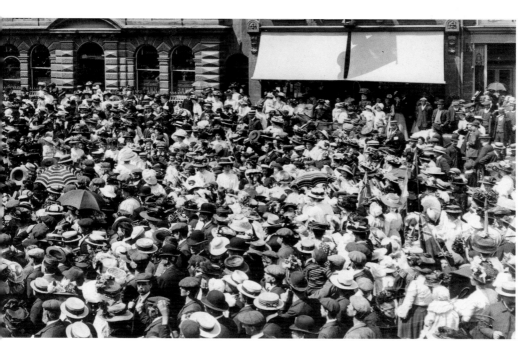

rowds in the Borough celebrating Empire Day.

The Yeovil Churches observed Empire Day on Sunday 23 May, with services in St John's, Holy Trinity and St Michael and All Angels, all of which ended with the playing of the National Anthem.

Earlier in the morning, the Yeovil Company of the 5th Territorial Battalion Somerset Light Infantry under the command of Captain Brutton, paraded in the Borough and led by the Town Band marched 'briskly' through High Street, Hendford and South Street to Holy Trinity Church the church of the company's chaplain. The *Gazette* noted with pride that 'Wearing the scarlet of their regular brethren, and being a well-set up lot, looked a credit to any Regiment, and shining example to the large number of youths and young men who later in the morning, whilst the National Anthem was being played, looked on indifferently, cigarette in mouth and without uncovering their heads.'

Following the service, the Yeovil Territorials and the Church Lads' marched back to the Borough where before a large crowd, they formed up and Colonel Marsh presented medals to Sergeant Sartin, and Privates E. Gerrard and E. W. Lucas, for long service, and Sergeants R. S. Gibbs, A January and J. Perkins (Langport), Corporals A. Gough, F. England and H. Russell. Lance-Corporal H. Beare, and Privates A. Cook, E. Curtis and E. Gillard for efficiency. Colonel Marsh then gave rousing speech, the National Anthem was played, and the ceremony brought to a close.

Monday morning, 24 May Empire Day, dawned fine and sunny, and saw the 'town very much beflagged, the many staves bearing the National colours in one form or another, whilst several business houses displayed strings of coloured bunting'.

The children of Huish, South Street, Reckleford and Pen Mill Schools were given specially prepared lessons following which they marched with flags waving to the Borough. In 1906 things were just as likely to go wrong as now, but despite the initial lack of arrangements, once assembled, the children sang several patriotic songs, were addressed by several local dignitaries. At the conclusion, Colonel Marsh exhorted the youngsters to 'Fit themselves to be citizens of the Empire. Everyone one of them who did their best, was a source of strength, but the loafer who did nothing, was a terrible source of danger to the Empire.' The Union Flag was saluted the National Anthem sung, and to much cheering, a half-holiday was announced. For Yeovil children it was a day to remember.

May, 1946

Twelve months after VE Day in May 1945, and nine after VJ Day the following August, servicemen and women were still coming home, and on 1 May 1946 the Yeovil South Street Baptist Fireside Club held a 'Welcome Home Supper' for thirteen men recently returned from the Forces. On June 1946, there would be a Victory-Day March in London, and Mr A. N. Perry of 11 Roping Road, a member of No. 2 Platoon Yeovil Borough Company, would be one of five former Home Guards selected to represent the 3rd Somerset Battalion Home Guard, on the March.

The Yeovil Cycling Club's first evening run of the summer was led by Mr J. Gould over the moors to Muchelney and Thorney, and back through South Petherton, Stoke and Montacute. The first Sunday run saw ten members enjoying tea at Rodney Stoke, after a windy ride across the Levels, and the party cycled home via Wells.

May 1946 also saw the inauguration of the Yeovil Mesopotamia Association of ex-servicemen who had served in Mesopotamia (now Iraq) during the First World War 1914-18. The members

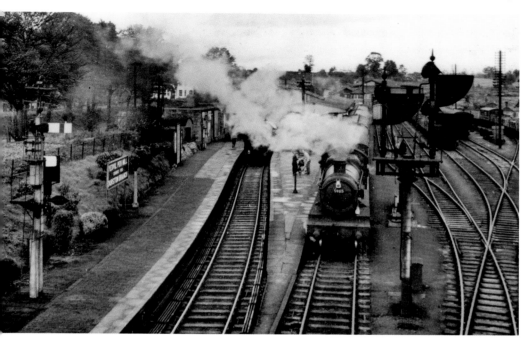

The Great Western Railway's summer timetable came into effect at Pen Mill Station on 6 May.

greed to form an old-time dancing club and the first reunion supper and dance would be held at Grove House (now the site of Legion Road) in mid-May.

The Great Western Railway's summer timetable came into operation on Monday 6 May with an improved service between Yeovil Pen Mill and Weymouth of fourteen down-line trains on weekdays, fifteen on Saturday and six on Sunday; on the up-line, there would be fifteen trains Monday to Saturday and six on Sunday.

Thirty girls were being 'rigorously trained' at Summerleaze Park School (Parcroft) to represent the South West of England in the 'Keep Fit' demonstrations and national dances at the National Festival of Youth to be held at Wembley before the Duchess of Kent, in the coming July.

The spring of 1946, saw the discovery of two Roman Villas in the area. One was at Lufton, where excavation was carried out by boys from Yeovil School under the direction of Mr Leonard C. Hayward, the Senior History Master; the work would continue for several years and many of the finds are stored in South Somerset District Council's Cultural Heritage Access Centre at the Lufton Depot. The second was the discovery and excavation of part of a large villa complex at Low Ham, near Langport. A fine mosaic pavement from the villa is displayed in the Somerset Museum at Taunton.

And finally in May 1946, Mr William Baker of East Street, West Coker, completed sixty-two years service as a line and cord maker with the same firm of Messrs Job Gould & Sons Ltd, West of England Twine Works, where he had started part-time work at the age of ten.

June

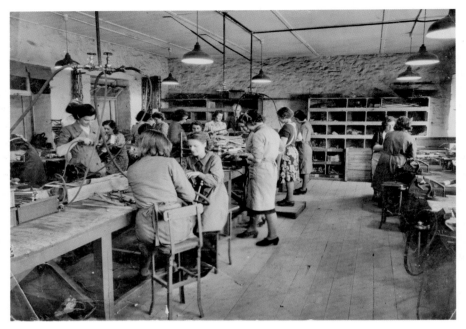

A Westland Aircraft workshop at an unknown war-time dispersed location in 1942.

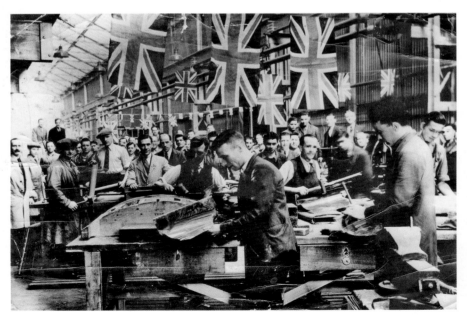

Westland Aircraft's sheet metal shop with flags and bunting celebrating VE-Day 1945.

une, 1885

)n the 5 June 1885, the *Western Gazette* gives us a glimpse of Yeovil in the mid-1880s, and its »rand new swimming baths opened the day before on the 4 June.

Few towns of its size and importance have spent more on public improvements during the past 20 years than Yeovil, and in few instances has the outlay been more judicially effected, or more completely justified by the results. It is but 30 years since the town was incorporated [Yeovil Borough Council was established in 1854] and already the place has been entirely transformed. The narrow streets have been gradually widened to such an extent that some of them are almost transformed. Paved or asphalt footways measuring miles in length in the aggregate, have been either newly constructed or entirely re-laid, and on the principal approaches to the town, these have been pushed out to the utmost limits of the borough, or even beyond. A complete system of sewers has been laid in all the streets, and surface gutters with numerous gratings are now almost universal. The roads are well cared for; their form and condition are well maintained, and they will, we believe, compare favourably with the roads of any borough in this part of the country.

The fire brigade is a volunteer body, it is true; but it has always been closely connected with the Council, and has been liberally supported in its efforts to render our splendid water supply available to prevent or extinguish fires.

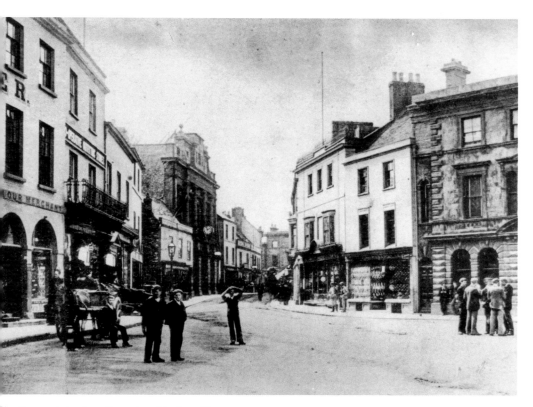

'he Borough in the 1890s devoid of traffic.

And this suggests to us the greatest, most costly, but at the same time the most valuable public work ever undertaken by the Corporation – the introduction of an unfailing supply of water at high pressure. If the incorporation of the town had never resulted in anything but this, it would have been fully justified. Our waterworks, are beyond question, the most valuable property we possess as a community. They are already a source of profit, and to the next generation of Yeovilians they will bring a revenue equal to at least one half of what is now raised by means of borough and highway rates.

But for our waterworks, it is safe to say that the ceremony of opening the new Corporation baths of yesterday would never have been performed. The fact that a large quantity of pure water – the property of the town – was flowing away to waste, naturally suggested the establishment of baths; and the suggestion at last grew into a proposal, and the proposal into a resolution, and the resolution into orders to architects and builders; and lo! we see the result – a set of baths which are an ornament and an honour which cannot fail to be a blessing to the town.

Yeovilians, being Englishmen, are, of course, apt to grumble at what their local administrators do or fail to do; and we are not concerned here and now, to maintain that grumbling has not its merits. But the present occasion of the opening of the Corporation baths is, it seems to us, one on which the public appreciation of their efforts to add another to our numerous public institutions ought to be gratefully and generously recognised by the public in whose interests they have been labouring.

The Grand Opening of the Yeovil Public Baths in 1885

In the previous article I described Yeovil in June 1885 at the time the new Corporation Baths were opened in Huish, and now I'll tell you about the grand opening event.

For many years, Yeovilians swam and enjoyed informal water sports in the River Yeo, and the most favoured bathing place was Cricketsham, in Newton Park, near the bridge which carried the railway line from Yeovil Town Station to Yeovil Junction. However, there was a serious problem, the river was deep, and over the years there had been a number of tragic drownings at Cricketsham. As a result many townspeople had been pressing the Borough Council to provide modern up-to-date bathing facilities under powers provided in the Baths and Wash-houses Act. In June 1885 the baths were opened and swimming in clean water was obviously preferable to swimming in a muddy, weedy and dangerous river.

In 1884, the Borough Council commissioned Mr Johnson, ARIBA, of London, the architect who had designed the new Yeovil District Hospital at the Five Cross Roads, to draw up plans for public baths to be built on land purchased from Mr Felix Curtis (after whom Felix Place was named), and seek tenders. The successful contractor was Mr Fred Cox, builder, who had built the new hospital, and the scheme was valued at £1550.

At eleven o'clock in the morning of Thursday 4 June 1885, the Mayor, Councillor Edwin Helliar, Aldermen, Councillors and invited guests assembled in the Corn Exchange next to the Town Hall, and toasts to 'The Queen' and 'Success to the Baths' were drunk 'with enthusiasm'. The official party led by the Volunteer Band, then proceeded around the Borough, along High Street, through Hendford and down West Hendford, up Felix Place and through the entrance to the new baths, where 'a large number of ladies and gentlemen were assembled'. The official party was accommodated on a tiered platform erected at the shallow end.

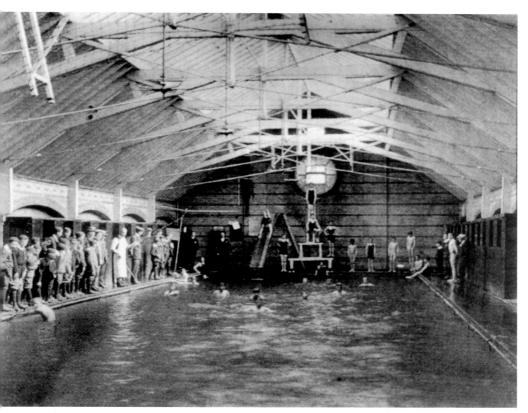

oys of Yeovil School receiving swimming lessons in the Yeovil Public Baths a century ago.

Following prayers, the Mayor declared the baths open, and Professor and Madame Darnley Mitchell, described as 'The Champion Lady Swimmer of the Clifton Baths, Margate', provided programme of 'clever performances in the baths', accompanied by music from the Volunteer and.

After a short interval, the Mayor and the official guests returned to the Town Hall, and at two 'clock sat down to a public luncheon. Toasts were drunk to the 'House of Lords and Commons' nd again to 'The Success of the Baths', to which Professor Darnley Mitchell responded by saying nat the Yeovil Baths were the best and prettiest he had seen. The architect, Mr Johnson, told the ssembled guests that the Yeovil Baths were larger than those at Liverpool and Birkenhead, and e did not know of any town of similar size, which could boast such baths as Yeovil had.

On the Thursday evening Professor and Madame Darnley Mitchell entertained a large udience to a swimming display, followed by 'an exhibition of the lime-light by Mr. Payne', everal swimming competitions, and music from the Volunteer Band.

The Darnley Mitchells performed again the next evening, Mr Payne exhibited his lime-light, iere were more swimming competitions, and Mr Milborne's string band played a selection of iusic.

It was reported that 600 people attended each evening's entertainment and, bearing in mind ie size of building, they must have been well packed in.

The facilities at the baths would be improved during the next half century, but they would retain their general capacity and configuration until 1961/62 when the old buildings would be demolished and the new swimming pool built on the site.

Freedom of the Borough to HMS *Heron*

At a Special Meeting on 21 May 1962, the Yeovil Borough Council resolved to:

> Recognise the glorious achievements of the Royal Navy and to foster the close and cordial association which has existed for twenty one years, this Council do confer upon the Captain, Officers and Ship's Company of Her Majesty's Ship Heron (Royal Naval Air Station, Yeovilton) the Honorary Freedom of the Borough of Yeovil.

The Honorary Freedom was a means by which a Borough Council could recognise persons of distinction and those who had rendered eminent services to the town. An Honorary Freeman acquired no rights in corporate property and no privileges, except those of a ceremonial nature. It was also customary for Boroughs to confer Honorary Freedom on units of Her Majesty's Armed Forces which had had local associations, to record the esteem and friendship of the townspeople. To mark this special relationship the unit was invited to march with colours, bands and fixed bayonets on all ceremonial occasions within the Borough. However, the legal power to confer Honorary Freedoms by Borough Councils ended in 1974 following the reorganisation of local government.

The ceremony of conferring the Honorary Freedom on HMS *Heron* was held at the Yeovil town football ground in Huish, on Saturday morning, 16 June 1962, when in perfect summer weather, a large crowd watched the 500 sailors and Wrens parade to the music of the Band of HMS *Heron*. At 10.50 precisely in the Municipal Offices at King George Street, the Mayor Alderman CE Hawes, accompanied by the Deputy Mayor, Alderman J. Kelly, and the Town Clerk, Mr T. S. Jewels, received Captain RHP Carver, CBE, DSC, RN, the Commanding Officer of HMS *Heron*, and the official party then proceeded by car to the Football Ground.

At 11 o'clock, the Parade came to attention as the Mayor and his party walked in procession to the dais where he was received by a general salute. The town clerk read the Certificate of Admission to the Honorary Freedom of the Borough, and the parade stood at ease. The Mayor then addressed the Ship's Company. It was more than twenty-one years ago, he said, that Yeovilton first became part and parcel of the life of Yeovil. 'At the outset many of us trembled somewhat and wondered what effect it would have on our daily routine. We had a few shocks, it is true, but these were eventually overcome, and today you can see the answer.'

'Over the years', the Mayor continued, 'associations had been formed, many sailors have married local girls, thousands of townsfolk have been to the Air Station, and sport had played a great part in making friends. We know that the bond which exists between us today is being continually strengthened, and today's ceremony is an example of what the people of Yeovil think of their neighbours who were good enough a few months ago to present the town with a silver heron to mark twenty-one years of friendship.'

A fanfare was sounded by Royal Marine buglers as Captain Carver stepped forward, the Mayor presented him with the silver casket containing the Freedom Certificate and asked the

he Band of the Royal Marines Beating Retreat in the Borough.

aptain to sign the Freemen's Roll. In reply, Captain Carver expressed his deep gratitude for the nonour conferred upon HMS *Heron*, and the Officers and Ship's Company were very conscious f the compliment being paid to them. The Freedom of the Borough would be cherished and well arded.

Led by the Band, and with CPO Moxey and the silver casket in pride of place, the parade arched with bayonets fixed through the crowded Borough, past the war memorial where the ayor took the salute, down Middle Street to the applause of townspeople lining the pavements, d dispersed in Newton Road. During the ceremony at the football ground, Yeovil Unit 548 of e Sea Cadet Corps, paraded at the arrival and departure of the Mayor, and at the saluting base the Borough during the march past.

The Band of HMS *Heron* gave a concert in Sidney Gardens during the Saturday afternoon, and e Royal Marines Band of the Flag Officer Air (Home) Beat Retreat in the Borough at half past x that evening. The day's events ended with a dance for the Ship's Company in the Assembly ooms.

June, 1950

Was it over sixty years ago I went to see John Wayne in *She Wore a Yellow Ribbon* at the Odeon Cinema in the first week of June 1950? It doesn't seem so long ago. Perhaps it's because the film is shown from time to time on TV that it is not so easy to forget. However I didn't go to see Betty Grable in *The Beautiful Blond from Bashful Bend* at the Gaumont, or *Border Incident* at the Central, and I can't recall these ever been re-shown on TV.

Other entertainments that first week in June 1950, included a Variety Concert by the St John's branch of the Girls' Friendly Society and the Music Group held their monthly members' concert possessing 'a sunny quality well in keeping with the glories of the weather outside'. A foundation day social organised by the Yeovil Young Liberal's General Committee, attracted well over 100 people to the Liberal Hall on 1 June, and the 'Coker Co-eds' entertained with a programme of 'music, monologues and burlesque' followed by dancing, games and novelties; music was provided by Stan Russell on the piano and Ken Rawlings' accordion.

Builders Messrs R. Shillabeer & Sons took their employees and their families for the firm's first annual outing since the war on a trip up the River Dart and lunch was taken at Totnes. Thirty members of the Holy Trinity Parish Fellowship went to West Bay on 6 June for their monthly outing.

On Saturday 3 June, the Yeovil Cycling Club set off in glorious weather from the traffic lights at the junction of High Street and Princes Street on a tour of beauty spots in West Somerset. First stop was at Taunton, then on to Williton, and after a tough climb they reached Selworthy Beacon where lunch was eaten. The afternoon run took the club to Wheddon Cross, over the Brendon Hills to Waterow for tea, and then back home through Wiveliscombe and Taunton.

The Yeovil Cycling Club set off on a tour of the West Country from these traffic lights.

Cyclist and athletes were in action on 3 June at the Huish Football Ground in what was described by the *Western Gazette* as 'one of the most exciting sports meetings ever staged in Yeovil.' The meeting, organised by the Yeovil Town Football Supporters' Club and Yeovil Cycling Club, was reported by the *Gazette* to have attracted national and West Country cycling and athletics personalities, and attracted a crowd of over 2,000 spectators.

Drama occurred shortly before mid-day on 7 June at Westland airfield. One of three Thailand Air Force officers on a training course was making a solo flight in a Westland S51 helicopter, when he crashed about 300 yards from houses in Watercombe Lane. The aircraft was extensively damaged and the Thai Squadron Leader was taken to Yeovil Hospital with head injuries.

In 1950, continental travel could be quite an adventure and on 9 June the *Western Gazette* reported that:

With only six shillings left in their pockets, two young Yeovilians have just returned from an eventful tour of France and Switzerland. They are Robert Reece of St Michael's Avenue and Dennis Berryman of West Hendford.

After landing at Le Havre, the couple visited Rouen, Paris, Versailles, Orleans, Dijon and Geneva, and during their 16 days of travelling covered 1,500 miles.

During their tour they sampled life in Paris. Armed with a tent, they pitched it in the Bois de Boulogne – France's equivalent of our Hyde Park. Next day some Frenchmen "almost tore their hair out" when they heard where the two Englishmen had had the "innocent" audacity to sleep. When they did not pitch their tent, the two young Yeovilmen, passed the night in small hotels – or even, once or twice, in railway waiting rooms!

With some shrewd economy they were able to make their money last out over the fortnight or so – but it was a very close thing. prices seemed at times, strangely out of line with this country. Whereas travel and hotel accomodation was cheaper, food was much more expensive. A pound of butter cost, in English money, as much as five shillings.

The couple told a reporter that they encountered fewer difficulties than they expected. People proved very co-operative and friendly, and they seldom went short of rides over the long, tiring routes.

Their school knowledge of French they found invaluable. They got on generally surprisingly well in conversation with Frenchmen, although there were moments of embarrassment. Especially hectic was the ordering of meals in French restaurants, when they attempted to combine the qualities of mental alertness, diplomacy and luck, in an effort to get the course they wanted.

Roughest passage in their long, touring holiday came on the return to England from Le Havre to England when seven of their ten fellow travellers were violently seasick.

And finally, nineteen infants from Yeovil and district, (including three sets of twins from Stoke-sub-Hamdon) were photographed as 'diminutive ambassadors' for the Welfare Food Service operated by the Ministry of Food. Sitting astride two large boxes of National Dried Milk tins and in 'armchairs' formed by cartons of orange juice, the youngsters were snapped individually and in groups as part of a special publicity campaign. The photographs were displayed at the Yeovil Food Office.

July

M A. S. R. Lewin's entry 'The Westland Walloper' in the Yeovil Hospital Carnival procession on 7 July 1923.

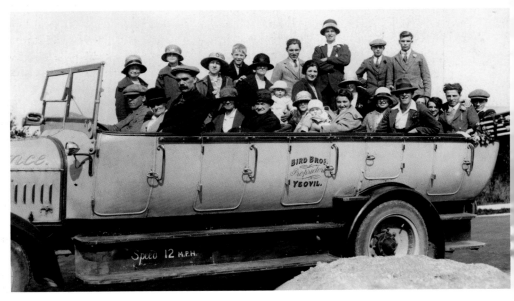

An outing in a Bird Bros. charabanc in the summer of 1926.

ıly, 1856

ı 1856, the Crimea War ended, the Victoria Cross was instituted 'For Valour' by Queen Victoria ıd in the Himalayas, Mount Everest was named after Sir George Everest, who had taken over ıe Great Trigonometrical Survey of India. Condensed milk was developed, and in the United ates of America, Isaac Singer offered trade-in allowances and instalment purchase for the first ne for the purchase of his sewing machines.

In Yeovil in July 1856, following the recent Bath and West of England Show, the *Western ying Post* described John Hill as the 'best carriage manufacturer in the West' and the show dges announced that his carriages 'exceed anything in workmanship, lightness or design yet ıtroduced'. In the years to follow the firm under the name of Hill & Boll, would live up to the ıper's description and become known as one of the best coach and carriage builders in the ıuntry; the firm would build the pioneering Petter's horseless carriage powered by a single- linder, 1 hp engine in 1895.

Misprints in newspapers were not uncommon in 1856, and the following item appeared in the *estern Flying Post* on 8 July:

BATH AND WEST ENGLAND AGRICULTURAL SOCIETY

A paragraph in our last (extracts from a Bath paper) announced that it had been resolved to discontinue the Society's annual show. It should have been the "winter show".

tters were delivered in Yeovil three times a day, at 8.15 a.m., 11 a.m., and 6.30 p.m., and letters ısted in the town before 10.30 a.m. were delivered to Sherborne, Cerne Abbas, Dorchester, ·idport, Lyme Regis and Weymouth during the same day.

Mr P. Berry begged to inform the Clergy, Gentry and inhabitants of Yeovil, that having cceeded Mr Brown in the Improved Collodian Process of Photography, he was prepared to ke portraits at Perry's Temperance Hotel in South Street at prices which could not fail to ensure mplete satisfaction.

You had to be fairly well-off to have your picture taken, and also to enjoy the Yeovil Fine Arts hibition at the Institution in Church Street. Admission was one shilling, reduced to sixpence ı Mondays, but increased to two shillings on Saturdays; a glover on average wages earned out £1 a week in 1856, and a labourer would be lucky to receive ten shillings!

On 1 July, the workmen employed by glove manufacturers, Messrs Bide & Hill, invited their ʼo employers to a dinner in one of the lofts of the new factory built in Reckleford. The loft was corated with flags and evergreens for the occasion, and over 158 people sat down to the fine read of 'various joints of meat and vegetables in profusion' provided by Mr Tom Woolmington the White Lion Inn. Toasts followed the meal, there were songs which included 'The Peasantry England', 'A Jolly Old Farmer was Sitting One Day' and 'Brilliance the Pride of the Ocean', ıd Messrs Bide & Hill were each presented with a silver tankard and a silver goblet inscribed as llows: 'Presented to Mr. Bide and Mr. Hill by their workmen as a mark of the esteem in which ey hold them as employers – July 1 1856'. More toasts followed, and at 7 o'clock dancing began the Workmen's Band and continued unbroken into the early hours of the following morning.

In the first town magistrates' sitting of July 1856, Samuel Butler was charged with stealing a ›e belonging to John Chant – keeper of a local beer-house. The court was told that Butler had ent three nights at the beer-house before he was employed in hoeing turnips in Mr Stone's field

Messrs Bide & Hill were entertained by their workmen in one of the lofts of their new glove facto
on Reckleford.

at Pen Mill. The hoe had gone missing and was subsequently found by Mr Stone in his field at
identified by John Chant. However, a hoe, mattock and jacket belonging to one of Mr Stone
labourers had been taken and were found in the possession of Butler together with a pair of
leather reins and three brass buckles. Samuel Butler was found guilty and sentenced to six wee
in prison.

Thomas Hyde was found guilty and fined 8 shillings for driving his wagon in a furious mann
and crashing into Eli Symes' donkey cart, throwing the unfortunate Eli into the road.

Alfred Garrett was summoned for trespassing in fields belonging to George Wines wh
complained that 'A good persons were much in the habit of passing through his fields, ar
particularly on Sundays. His object was to prevent it.' Alfred Garrett was ordered to pay or
shilling damages for trespass, plus costs.

For many years the River Yeo was a popular bathing spot before the public baths were open
in Felix Place in 1885, but the river could also be a most dangerous place. At one o'clock o
Friday afternoon, 5 July, blacksmith James Cooper and his friends Philip Perry and Hen
King went down to the river for a swim in the popular bathing place called Spring Mead. Th
undressed, jumped in, swam up the river and then turned back. Suddenly, James Cooper beg;

struggle, and hearing his frantic calls for help, his two companions swam back only to see him ping under. Philip Perry managed to grasp his friend's head, but James desperately grasped his scuer's legs, and they both went down. Now fighting for his life, Philip managed to break free nd was helped from the water by Henry King. Two other bathers, solicitor Walter Rogers and is friend John Glyde were dressing nearby and on seeing James Cooper in difficulty ran to help ut were too late, the blacksmith had disappeared.

James Cooper's body was later recovered and the inquest was held on the following day in ne White Hart Inn when the verdict was returned of 'accidentally drowned whilst bathing'. The iry expressed their appreciation of the conduct of Philip Perry for 'his humane exertions in ndeavouring to save the life of the deceased'. The River Yeo was indeed a dangerous place, and ould claim more lives in the years which followed.

eovil Hospital Carnival, 1922

he *Western Gazette* reported on Friday 21 July 1922 that: 'The oldest residents of Yeovil on aturday declared that never in living memory had there been such a wonderful scene as the irnival procession which wended its picturesque way through the town in the afternoon'.

Saturday 15 July began fine and sunny, but by late morning the clouds banked up and everyone aced themselves for the inevitable downpour. However, the 'Gods of the Weather' smiled, and y noon the clouds had vanished, and the sun shone on the 60 tableaux, 300 or more walking tries, plus many decorated cars and motor cycles.

The procession set out from Sherborne Road, led by Red Indians on two motor cycles to clear e way, followed by the Salvation Army Band and a company of masqueraders on foot. The quire of Pen Mill' carried in his Sedan Chair, was given pride of place. Next came the Mayor, ouncillor E. J. Farr, driving his car, followed by the Town Band and the procession of decorated rries bearing the tableaux.

On the *Western Gazette's* lorry there was a printing press turning out leaflets with the order of rocession, and Denner's presented 'Henry VIII and his wives' on a lorry drawn by four horses, id led by the Yeomen of the Guard. The Yeovil and District Co-operative Society had a realistic akery and Boy Scout Camp. Huish School's 'Old Woman who lived in a shoe' was followed by e Huish Boys School Jazz Band with their ' KKK' conductor. A lorry carrying ' The Menagerie All Captured in Newton Copse' was reported to contain 'this fearsome collection, very rightly ged, but the source of much amusement'.

The Yeovil Volunteer Fire Brigade paraded the old manual fire pump complete with bearded tendants wearing old leather helmets, and followed by their new Leyland motor pump.

The walking entries included groups and individuals dressed in an 'amazing variety of istumes'. There were clowns, pigs, ladies wearing costumes consisting entirely of copies of the *estern Gazette* and *Pulman's Weekly News*, cowboys, Red Indians, Robin Hoods and a host nursery rhyme characters. Cadet and jazz bands played and decorated cars and motorcycles luttered through the town – all heading for the Fairfield in Huish for the judging. The bells of John's Church rang out a noon to welcome the hundreds who were pouring into the town to joy the parade.

At the conclusion of the parade, the crowds flocked to the town football ground in Huish for e Great Fun Fair. One of the major attractions was the wireless concert broadcast from the

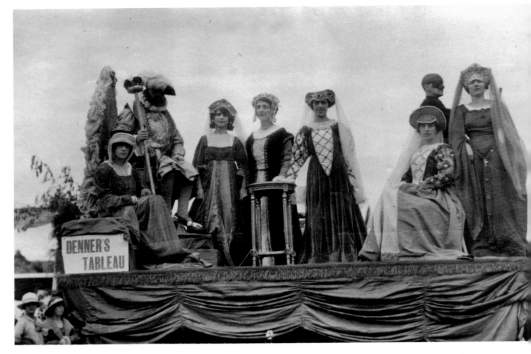

Denner's entry 'King Henry and his Wives', complete with executioner!

Eiffel Tower in Paris, and described by the *Western Gazette* as 'Unique and so wonderful that was not altogether unnatural for one or two village folk to suppose that the music or song hear was coming from a room above the Huish Boys School next door to the Ground'. There we tugs-of-war, pole jumping, a comic football match between the Toppers and the Clowns describe as 'one of the most extraordinary games ever played on the ground', a motorcycle gymkhana, Punch and Judy show, a performance from Great Erno the magician, Ereka the Manacle Kir fascinated, and the Robin Concert Party and the Yeovil Male Voice Choir entertained.

On Saturday evening a fancy dress dance was held in the Assembly Rooms in Princes Stree where the 'floor was crowded with dancers clad in all manner of attire, and the utmost goo humour prevailed'. The Prince's Orchestra played, and the Masters of Ceremonies were Messrs H. Burr and A. E. Sutton.

The Carnival raised £1,700 for the New Hospital Fund.

The Spanish 'Flu of 1918 and the Sleeping Sickness

With the introduction of annual vaccination for the elderly and not so fit, influenza is not th killer it was. However, influenza should not be taken for granted, because there is always th danger that one day an extremely lethal strain might emerge.

The misnamed Spanish 'Flu, which probably originated in China, turned into a fearf pandemic in 1918, and although the total number of its victims is unknown, it is believed th

etween 21 and 40 million of the world's people died; the virus killed some 150,000 in England nd Wales.

The virus took hold of the patient quickly with a cough, headache and a raging temperature of p to 104 degrees Fahrenheit. Although many recovered, death could follow from complications uch as pneumonia for which there were no remedies.

In early July 1918, the first Yeovil cases were diagnosed in the Pen Mill area but these were 1ild and all the patients recovered. Even so, the schools were closed on 16 July for several weeks ut thankfully the outbreak was over by the middle of August.

The 'flu erupted again with a vengeance in the second week of October; and this time the virus /as very nasty. It began once again in the Pen Mill area, probably brought in by railway workers oing from town to town and mixing with infected passengers, and spread rapidly across Yeovil.)n 21 and 22 October, all the day and Sunday Schools were closed and, by the end of the month, 1ctories and shops were short handed; the Borough Council's departments, most of which rere engaged in trying to fight the infection, were so depleted of staff that they almost ceased 1nctioning. The Albany Ward Picture Palace in the Triangle was closed to children and dances rere cancelled.

The epidemic reached its height during November, then gradually faded away and had ractically disappeared by Christmas. The virus in this second phase was the very dangerous rain, and the pneumonia, which could rapidly develop, caused nearly all the deaths in the)wn. Whole families could be simultaneously attacked and often there was great difficulty 1 getting them assistance. Both of the town's District Nurses went down with the virus and agically, twenty-six-year-old Nurse Gary died on 4 November, her condition being aggravated y attending a 'flu patient when she was very ill herself. A few days earlier on 1 November, 1r J. H. MacMillan, a Voluntary Aid Detachment member working in the Red Cross Military Iospital in the Newnham Memorial Hall in South Street, also succumbed to the virus. The nurses orking at the Westland aircraft works were brought in to help the town medical authorities, 1d the local doctors were put under tremendous pressure. One physician was away on military ervice, several went down with the 'flu and the town's Medical Officer of Health, Dr Weaver, und himself attending many of his private colleagues' patients who would otherwise have been ithout medical aid.

By the end of November the epidemic began to abate and schools and public places were re-pening, although the national Influenza Regulations which came into force on 18 November rohibited entertainments for longer than three hours without an interval of half an hour for the 1orough ventilation of the room.

The total number of deaths in Yeovil in which influenza was certified as the primary or econdary cause was 81 divided almost equally between the sexes, 40 males and 41 females. The ;e group twenty-two to twenty-nine, with twenty-two deaths, was the highest and at each end f the generations there were fatalities; one an infant under one year and one hundred-year-old eovilian. Mr. H. St. Clair, the manager of Albany Ward's Picture Palace, was one of the eighty-1e deaths.

The onset of the deadly Spanish 'Flu coincided with the end of The First World War and the 1tpouring of relief across the nation and Europe seems to have pushed this terrible epidemic to the back of folk memory. However, the eighty-one Yeovilians who died from the Spanish lu, sixty-three passing away in three weeks, outnumbers those who died in the bombing of the •wn in the Second World War.

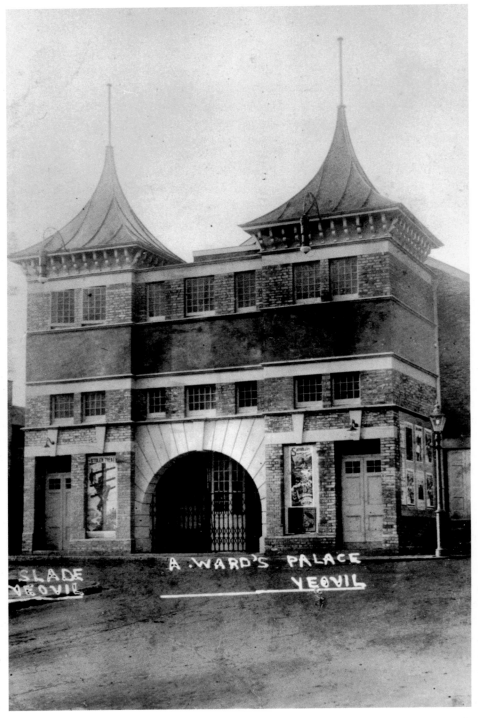

One of the victims of the Spanish 'Flu was the manager of the Albany Ward Picture Palace.

The world was still recovering from the deadly influenza pandemic of 1918 and the slaughter of the First World War, when a strange and puzzling illness broke out. The victims, especially young people, would go down with a high fever, headache and sore throat and develop a range of other alarming symptoms, including double vision, weakness of the upper body, tremors, strange movements, intense muscle pain, and perhaps the most frightening, drowsiness, lethargy, psychotic behaviour and in many cases prolonged unconsciousness. The cause and origins of the illness were a mystery, and it was given the Latin medical name *Encephalitis Lethargica* which means 'inflammation of the brain that makes you tired', but to the general public it would be known as the 'sleeping sickness'.

The sleeping sickness swept around the world and it was estimated that over a million people died, with a similar number left incapacitated. In 1928 it vanished as suddenly as it had appeared. The origin and cause of the sleeping sickness still remains a mystery and thankfully it has not reappeared in epidemic form.

In Yeovil, only Frederick Day and Richard Pinney were the tragic victims of this strange and frightening illness and there appears to be no further cases of sleeping sickness reported here.

July, 1943

The photograph accompanying this article was taken on the goods platform at Yeovil Junction 2 July 1943, and shows the Rail Transport Officer's staff, but only two soldiers have been identified by a note on the back of the original print. Sitting on the right of the photograph is a United States Army staff sergeant identified as 'Marco', and on his right is Royal Engineers sergeant N. B. Johnson.

The photograph has prompted me to take a quick look back to Yeovil in early July 1943 at the height of the Second World War. On 2 July the town suffered its 346th air raid warning of the war; there would be one more in July, on the 21st, both lasted a quarter of an hour. The last bombs fell on Yeovil in August 1942 and by July of 1943, the German Luftwaffe's activity over Somerset had declined considerably, and only seven more warnings would be sounded during the rest of the year.

Looking through the columns of the *Western Gazette* for the war years, it would be quite reasonable to assume by reading many of the articles that we were at peace and not in the middle of a terrible world war. For example, the Yeovil Labour Club's darts team were reported to have beaten their arch rivals, the Glover's Arms Inn, by seven games to two, and the Club's skittle team beat the Golden Lion (Park Street) by 20 pins.

Yeovil was experiencing one of the annual water shortages which had plagued the town for years and would not be finally solved until the Sutton Bingham Reservoir was opened some ten years later. Consumers were being exhorted to save water and avoid waste, a hosepipe ban had been imposed, and from 3 July until further notice, domestic water supplies would be turned off every night from 10 pm to 6.30 a.m. I well remember our bath being filled up every evening, together with buckets, bowls and pans.

Mr H. Seymour of Preston Grove wrote the following letter to the Editor of the *Western Gazette*:

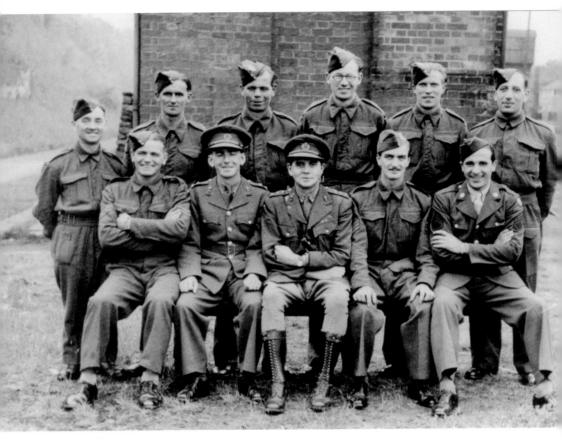

The Rail Transport Officer's staff at Yeovil Junction.

Cannot something be done to abate the very great smoke nuisance coming from the Gas Dept. furnaces in Yeovil, it fouls the air around for a great distance. I understand modern gas undertakings in other districts have done away with this corruption of the air, this danger to health. What is to be done?

All the previous articles from the columns of the *Western Gazette* could have been taken from any of the pre-war years, but further reading would soon dispel all such notions. On 2 July the *Gazette* reported that Mr and Mrs Barlow of 48 St Michael's Avenue had received official notification that their son, Arnold, a Sergeant Observer in Royal Air Force Bomber Command, was reported missing on recent air operations over Nazi Germany. Sergeant Barlow was in the crew of a Lancaster bomber shot down near Cologne on 25 June; he is remembered on the Yeovil War Memorial and on the RAF Memorial at Runnymede.

In 1943, there were strict laws relating to employment, and on the application by the Ministry of Labour and National Service, the magistrates issued a warrant for the arrest of an employee of a Yeovil company who had been absent from work without permission on a number of occasions and who had refused to answer a summons.

August

The obstacle race at the August 1908 *Western Gazette* Athletic Sports in Newton Park.

Starting one of the cycle races at the August 1908 *Western Gazette* Athletic Sports in Newton Park.

August, 1914

On the afternoon of Tuesday 4 August 1914, the Prime Minister, Mr Herbert Asquith, announced Great Britain had declared war on Germany. So let's take a quick look back at those high summer days of late July and early August 1914 in the memorable words of Lord Grey – 'The lamps are going out all over Europe; we shall not see them lit again in our lifetime.'

On 30 July the choirboys of St John's Church went on their annual outing to Weymouth partly paid for by an organ recital by their choirmaster and organist, Mr Risdon, and where they were provided 'with dinner and tea and spent a very happy day'.

On Sunday 2 August Mrs Seymour, the leader of the Congregational Church Primary Department, retired after fifty years working for the Sunday school. She was presented with a large photograph of the infant class and a 'purse of gold' from the teachers and helpers of the Sunday school.

During the last week of peace, a party of West Indians led by Staff Captain Narraway visited the Yeovil Salvation Army Temple and the services of celebration included a special open air meeting in the Triangle.

The Town Council's last peace time meeting was held on 13 July and there is no hint of the coming crisis. Business included a discussion on the town water supply and a suggested new

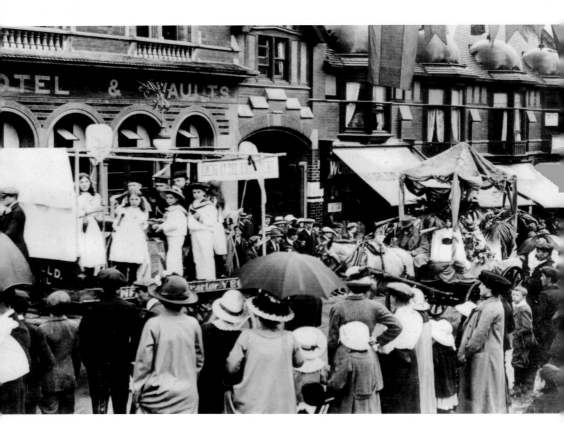

The Blue Marine's tableau passing the Coronation Hotel on its way with the procession to the fête at Yew Tree Park.

reservoir off the West Coker Road, arrangements to inspect the Eastland Housing Estate, an nsanitary building in Middle Street, West Hendford drainage, repairs to the Sherborne Road drinking fountain, the preparation of a town planning scheme, the purchase of apparatus to examine diphtheria swabs etc., the Medical Officer of Health's monthly report and so on.

At the town magistrates court, an impecunious local hair dresser, when fined 2s 6d for using indecent language, said that if he paid the fine there and then, he would not be able to go to the fête and asked if he could pay the following Saturday. The request was granted.

The fête, which the defendant was so anxious to attend, was the Conservative and Unionist Fête of the West,' one of the highlights of the year, to be held on Tuesday 4 August at Yew Tree Close Park. There would be a Flower Show, Athletic Sports, Daylight Carnival with 'pretty scenes and tableaux', a Grand Procession from Wyndham Fields led by bands and lodges of the Blue Marines, Variety Entertainments by 'Clever Star Artists,' a grand display by Brock of Crystal Palace fame, illumination of the grounds and performances by the Yeovil Military and Crewkerne Town Bands. Yeovil's MP, the Hon. Aubrey Herbert and George Lloyd Esq. MP, would speak at the Fête. Cheap railway tickets were available for patrons from all stations with forty miles of Yeovil. Despite the impending declaration of war, the fête went ahead, but the party political element was removed and instead, patriotic letters were read from the two MPs, now present in the House of Commons.

Within weeks of the declaration of war, local army and naval reservists had been recalled to their regiments or ships, Special Reservists, Territorials and the first volunteers for Kitchener's Army had left ... Still they wouldn't be away for long because hadn't everyone said that the war would be over by Christmas!

The *Western Gazette* Athletic Sports

During the early years of the last century, one of the highlights in the Yeovil area was the day of the *Western Gazette* Sports, and what a day it was. Competitors came from far and wide; both for the serious sports and the fun ones, and the spectators could be counted in thousands.

On 15 August 1908 there was a record attendance of over 3,000 people in the field at Newton Park, and a very attractive programme had been arranged by the Committee.

The *Western Gazette* reported that:

The card altogether comprised 18 events and the open ones which brought competitors from all over the district, were well filled up, and some of the best cycle and foot racing ever scene in the district was witnessed, the finishes being very close. A course of five laps to the mile had been prepared, but owing to the long spell of dry weather, the ground had become very hard and "bumpy" in places, despite the work of the roller. Happily, however, not a single mishap occurred. Much interest as usual, was centred on the tug-of-war tournament for the Western Gazette Challenge Cup. The Nautilus Works No 1 team having previously won the cup twice in succession, and again winning it on Saturday, it now becomes their own property. Each member of the team also received a silver medal with gold centre. The tug-of-war between the Western Gazette married and singles was won by the former team. The donkey race was again a novel item, the competitors being required to lead the animals one lap, ride the donkey the second, and harness up and drive the last lap. All the animals went well for the first round, but much

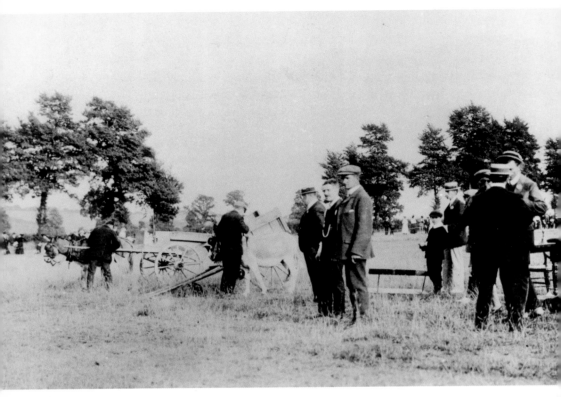

Awaiting the start of the donkey race.

amusement was caused on the second, the rider of the "Newtown Scorcher" – which at times belied its name – being thrown several times. After this little diversion, "Scorcher" went well, and obtained the second prize. The other events were keenly contested, the cycle races proving the most popular. Some splendid high jumping was witnessed and, although there were several competitors from a distance, Harris, the local favourite, secured the palm with excellent jump of 5ft. 1in.

Yeovil and the War

On 4 August 1914, Great Britain and her Empire declared war on Imperial Germany, but the war which was confidently expected to be over by Christmas would last for another four years. Tragically, over 200 Yeovilians who enjoyed that warm August Bank Holiday Monday would die in the conflict and hundreds more would suffer wounds and illness.

From 14 August 1914 to 17 January 1919, the *Western Gazette* reported on Yeovil's role in war in a weekly column, and here are a few of these reports.

The first article on 14 August reported the departure of 'D' Squadron of the West Somerset Yeomanry cavalry from the Town Station on 10 August, *en route* for Winchester, to the rousing cheers of the townspeople lining the platform.

'D' Squadron of the West Somerset
Yeomanry passing along High Street
on 10 August on their way to entrain.

During the weeks which followed patriotic feelings were running high, and on 28 August it
was reported that – 'Recruiting was proceeding at a fairly satisfactory rate. During last week
twenty-three men enlisted and up to yesterday morning (Thursday) twenty-one recruits had
joined the colours'.

By November, the column was reflecting the true cost of the war with reports of deaths and
wounding, but there was still hope in some minds of an early end to the conflict. Letters home
could still be full of enthusiasm, even after fifteen months of conflict, and on 19 November 1915,
Private George Forsey (3rd Grenadier Guards and my late mother's step-father) wrote from the
front to a friend at the *Western Gazette*:

Tell all the boys at home to make haste and come out here. The Germans cannot frighten them
for as soon as you get them in close quarters they cry for mercy – which they always get (I don't
think). I suppose you have read Sir John French's account of us at Loos, and other places. It was
a bit hot, but the Guards kept smiling and marched as though they were on parade through
London.

George, who as a former Regular soldier with the Grenadier Guards had been recalled to the
colours in August 1914, survived the war and returned to his foreman's job with Messrs Petters.
On 26 July 1918, the war neared its fourth anniversary.

Lance Corporal B. Jennings, Wilts Regiment, son of Mr and Mrs S Jennings of 102 Park Street, has been missing since 31st May. He joined up when 18 years of age last October and went to France on Easter Tuesday. He was formerly a Patrol-leader with the Boy Scouts and a member of the Men's Voluntary Aid Detachment.

The fighting and killing stopped on 11 November 1918, but the column of 22 Novembe recorded that:

The deepest sympathy has been expressed with Mr and Mrs Hockey , of Pen Field, Sherborne Road, who, during the Armistice rejoicings, received the news of the death of their son, Private H. Hockey, of the Machine Gun Corps, who was killed only two days before the cessation of hostilities. The deceased was well known, and the news of his death at the age of 24 was received with regret. He had only been married about five months and was drafted to France on 9th October, having thus served abroad only one month. The deceased was previously employed as a clerk by the Phoenix Engineering Co. Ltd., Chard, and was also a keen footballer.

On 17 January 1919, the last report of the last column of 'Yeovil and the War' was, 'The Militar Medal has been awarded to Lance-Corporal Leonard Gordon Stacey of the 2nd Canadia Infantry Battalion. He is the second son of Mr H. C. Stacey, late of Mostyn, Sherborne Roac Yeovil, and now of Hove, Sussex.'

August, 1945

By the first week of August 1945, the war in Europe had been over some three months, bu thousands of miles away in the Far East, the war was still being waged against an increasingl desperate Japanese Empire.

Back at home, the General Election had been held on 26 July, the Labour Party had won landslide victory and Mr Clement Attlee was the new Prime Minister. In the Yeovil Constituenc Lieutenant Colonel W. H. Kingsmill, the Conservative Candidate, defeated his Labour opponen Major Malcolm MacPherson, by the wafer-thin majority of 174 votes, 16,815 against 16,641.

A sign that things were beginning to get better, despite the continued rationing and shortage was motor dealers Messrs W. Sparrow & Sons announcing in the *Western Gazette* on 3 Augu that NEW CARS were available.

The first Monday was the August Bank Holiday and during the preceding week it was estimate that over 9,000 Yeovil people left for the seaside or other holiday resorts. Looking back over th holiday the *Western Gazette* wrote that:

The "Great Exodus" began the previous Monday, and reached its climax on Saturday when Yeovil glove-workers swelled the holiday crowds. The factories are closed this week for the annual holiday but this year employees get an extra day. Hitherto they had lost the benefit of the Bank Holiday and under a recent agreement this was recognised. To make up for the lost day the factories closed on Friday mid-day, instead of Saturday.

Queues for the London train, Lyme Regis and other resorts began forming at the Town Station before five a.m. on Saturday and by mid-day over 1,000 had left.

ver 1,000 travellers had left Yeovil Town Station by mid-day on August Bank Holiday Monday.

Thursday's crowds were nearly as big as Saturday's and on Friday the waiting hundreds mopped their brows in a temperature of 85 degrees in the shade.

From Monday to Sunday Pen Mill coped with about 4,000 to Weymouth, and about the same number travelled to Lyme Regis and Seaton from the Town Station. The traffic was 25 per cent heavier than last year. Buses from Yeovil to Bournemouth had to be duplicated and many people were left behind.

n 3 August the *Gazette* reported that the Town Clerk of Yeovil had received a letter from the own Clerk of Willesden, from which hundreds of women and children had been evacuated ring the war, expressing the sincere thanks of his Borough to the people of Yeovil and district r all the kindness and consideration shown to them during the time they had stayed in the ea.

In his annual report to the Borough Council, Mr E. A. Batty, the Librarian and Curator, stated at from 3 September 1939, when war broke out, to 31 March 1945, 1,173,651 books had been ued and the book stock now stood at 19846. He considered that the provision of a reference rary was the most pressing of the many urgent needs of the local library service.

Early on Monday morning 6 August 1945, the first Atomic Bomb exploded over the city of iroshima and three days later a second destroyed Nagasaki – Japan surrendered on 14 August, d the world would never be the same again.

September

Members of Yeovil Bowling Club in July 1911.

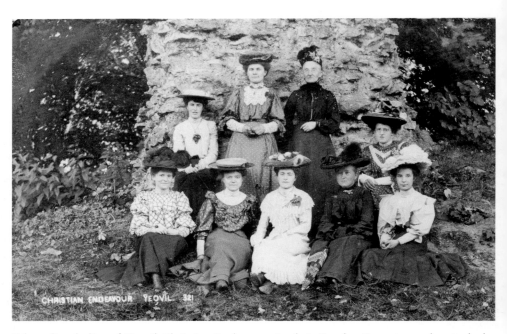

Edwardian ladies of Yeovil Christian Endeavour in their Sunday Best pictured at Jack the Treacle Eater in Barwick Park.

eptember, 1865

rly in September 1865, the following announcement appeared in the columns of the front page
the *Western Flying Post*:

HANNAM AND GILLETT
BEG to announce that they have DISPOSED of their BUSINESS to JOHN PETTER and take this
opportunity of offering their sincere thanks for the kind and constant support they have been
favoured with, and which they take the liberty of soliciting a continuance of for their Successor,
who, they believe, will be found worthy of general confidence.

mediately below, under the heading 'GENERAL FURNISHING IRONMONGERY', John Petter:

RESPECTFULLY announces to the Nobility, Gentry, Clergy and Inhabitants of the Town and
Neighbourhood of Yeovil that he has PURCHASED the STOCK and SUCCEEDED to the BUSINESS
of Messrs HANNAM and GILLETT, Ironmongers &., which he is now carrying on in all branches.

ho could have imagined during that late summer of 1865, the effect John Petter's purchase of
annam and Gillett's ironmongers' business in the Borough would have on future generations of
ie Town and Neighbourhood of Yeovil', and in the field of engineering and aviation. From this
imble beginning grew Petters & Westlands, and the rest, as they say, 'is history'.

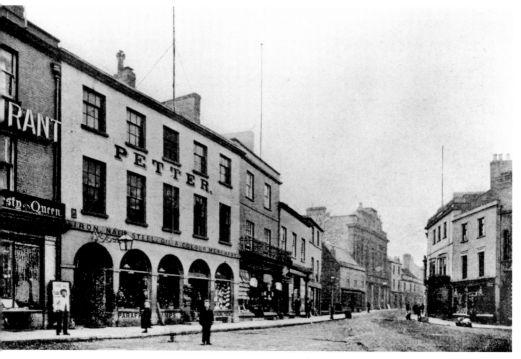

n the left is Petter's shop in the Borough where it all began in Yeovil.

On Tuesday and Thursday morning, 12 and 14 September 1865, the Royal Mail deliveries t
Yeovil were over an hour late on both days, but the fault was placed firmly on the shoulders o
the railway company concerned. Whilst on the subject of the railways, the *Western Flying Po*
reported that the Bristol & Exeter Railway Company had added some new first class carriages t
its rolling stock, and these were fitted with gas boxes to enable 'passengers to enjoy the luxury o
gas lighting during the winter months'.

Two young lads were playing with some gunpowder near the fire in the kitchen of Stuckey
Bank, when the flask containing it exploded. The flask was blown apart and a piece hit one of th
lads in his throat near the main artery. Fortunately the wound was not fatal and the youngst
was reported to be recovering well. It was also reported that the explosion was heard som
hundreds of yards away.

As autumn approached, outdoor activities were drawing to a close, but not before Odcomb
enjoyed the 'Pye Corner Diversions' on Tuesday 12 September, which involved 'The usu
programme of donkey racing, dipping for money, greased pole climbing, racing backward
jumping in sacks etc. The diversions lasted from half-past three till eight o'clock.'

At South Petherton, the inhabitants were thrilled to 'behold the welcome sight of gas lightin
the town for the first time, and are highly pleased thereat. It is hoped that the sister town Martoc
will shortly follow suit.' During the first weeks in September the streets remained in darkness as
was understood by the Editor of the *Western Flying Post* that the town council and gas compan
could not agree the supply price per lamp.

And finally, a little something for a country quiz night, taken from the *Western Flying Post*
19 September 1865: 'Energetic measurers have been taken to mark the public estimation of th
private worth and public services of Sir E. B. Baker. Sir Edward was the first person to introdu
steam machinery in connection with agriculture in Dorset.'

Looking Back

In September 1908, my late father was nine years old, and my mother nearly six years young.
I mention this unremarkable fact because it shows how many of us are linked to what seem
the distant past. One hundred and four years ago, both my parents were alive in a world
completely different from that of their one offspring, and this leads me to wonder what the wor
will be like should our three children look back from 2046 to 1946 when both their parents we
nine years old. Just a thought.

So let's have a look back to the Yeovil of my parents, over a century ago in the first wee
of September 1908. At their first meeting in September, the Borough Council declared Gro
Avenue to be a public highway, together with the length of Seaton Road in front of the recent
completed houses.

Ernest Tuck was cycling down Cemetery Hill 'at speed' in the rain with his head down, an
failed to see Mr J. H. Newis drive his pony and trap out of his yard and into Preston Road. Th
result was inevitable; Ernest cycled at full speed into the trap and sustained severe cuts an
bruises. The bicycle was badly smashed, but Mr Newis's trap was undamaged.

Ernest Tuck was not taken to Yeovil Hospital, and therefore did not become a statistic.
August 1908, thirteen patients were admitted, eight discharged, two died and at the beginning
September eight were receiving treatment as in-patients. Over at Martock there was an outbrea

eckleford in the 1960s had little changed since young William Browning was summonsed for rowing stones in 1908.

f measles and the Martock and Bower Hinton Schools were kept closed after the summer olidays; Yeovil and nearby villages appear to have escaped the disease.

However, there was some cheer at the beginning of the month, when Mr J. Bannister Howard's company presented the successful farce 'When Knights were Bold' on Wednesday and Thursday -10 September, at the Princes Street Assembly Rooms. The *Western Gazette* wrote that the now 'had been the success of the century in London where it has been played for nearly 600 erformances at Wyndham's Theatre. The arrangement drew large "houses" and was excellently cted throughout and the audiences were kept in a continued state of merriment'.

The town magistrates disposed of their business on 1 September in a swift seven minutes. William atts, a fish hawker, was charged with leading his horse and cart on the highway without a light. illiam's wife attended in his place and informed the Bench that her husband could not lose a day's ork, but the chairman told her that the hawker had been summoned and should have attended. fine of two shillings and six pence was imposed. Young William Browning appeared and after leading guilty to the charge of throwing stones on the highway in Reckleford, apologised for e offence. The Bench was told that there had been an outbreak of stone throwing in the town. illiam was given a stern lecture by the chairman and told that he was old enough to know better. he court was determined to stop stone throwing and William Browning was fined five shillings.

eovil School Remembered

n 16 September 1998, following a chat with Mr Martin Heal, the then Editor of the *Western azette*, I began a weekly column in the newly launched *Yeovil Times* on matters historical and

The School Army Cadet Force 1953 – Seated centre, Captain Tom Lumb, officer commanding, on hi left Lieutenant Peter Unwin, second in command, NCOs and senior cadets.

such like, transferring to the *Western Gazette* in the autumn of 2005. This is part of the firs article I wrote, the first of over 650:

Over the past few weeks another Yeovil landmark has rapidly disappeared. The old Yeovil School buildings in Mudford Road have been demolished to make way for a new housing development to be called 'College Green.'

The School was officially opened 60 years ago on the 30th May 1938 and ten years later in September 1948 I was one of the sixty three new boys starting in the First Form. I left in 1954 and twenty years later, in the new era of education, Yeovil School closed as a Grammar School and the buildings became part of Yeovil College.

Doubtless many of the former pupils will feel a pang of loss and the demolition of the School leaves me something of an 'educational orphan' because all the schools I attended have been demolished; one is the site of a block of flats in South Street and another is the Tesco Petrol Filling Station.

In an attack of nostalgia I looked out a copy of the School magazine called *The Yeovilian* for 1948/49 to recall some of the things which had happened during my first year.

The Yeovilian contained reports from the many and varied School clubs and societies. There was the Parents Association, the Choir and Orchestra, the Arts Club and the Archaeological Society, the Field Club reported on rambles in the country to the west of Odcombe and the Radio Club was working towards building its own transmitting station.

Eight members of the School Army Cadet Force spent a week in West Germany with the British Army of the Rhine and told how there was "desolation" around the towns and "rubble as far as the eye could see." One of the highlights of the week involved each cadet firing three bombs from

a 2 inch mortar followed by a demonstration of flame throwing and the 3 inch mortar; there were also exciting rides in troop carriers and a cricket match against a National Service team.

The Yeovilian was a mine of information on the activities of Old Boys in the armed forces, at university or college, pursuing careers and getting married. There were Notes on rugby, cricket and athletics. Reports came from the three School Houses - Kingston, Ivel and School - but of one event there is no mention even though it reached the national press. However let the book *1845 – 1995 – 150 years of Yeovil School and the Old Yeovilians' Association* tell the tale:

"A sixteen year old boy spent his last day at Yeovil School by dressing as a doctor and hoaxing the entire school. The school was expecting a doctor and before lunch a figure in a white coat and dark spectacles arrived. He told a prefect he wanted to examine the boys of the two junior forms. The prefect did not recognize the "doctor" in his father's trousers, and sent two senior boys to the form rooms. They asked the masters to send the boys up to the Library in threes – the usual procedure at medical examinations. On his way to the Library, the "doctor" passed four masters. They did not recognize him either. In the Library were two more masters. They said "good Morning". The "doctor" asked them to leave while he was examining the boys. They left. The boys were brought to the Library, where they were seen by the "doctor". One boy was told that he had a "punctured oracle", another was gravely informed that he was not breathing properly. The "doctor" insisted that all the boys drank a special medicine consisting of horseradish, salt and water and the boys then went back to their class rooms. There were no good or ill effects. The "doctor" sat for his school certificate last term and his masters believe he has passed as he was "one of the brightest boys in the school". "

Although the School died in 1974, its name and memories are still kept alive by the Old Yeovilians' Association with over 1000 members world-wide.

September, 1950

The Wooden Horse, one of the classic Second World War escape films was showing at the Odeon Cinema in Court Ash, during the first week of September 1950. Described as 'another true story of courage and heroism not to be missed', the film starred Leo Genn, David Tomlinson, and 1950s 'heart-throb' Anthony Steel. Accompanying the main feature was *The Holy Year* described by Wilfred Pickles. Showing at the Central Central Cinema in Church Street, was 'The Funniest Picture for Years and Years – *Adam's Rib* starring Spencer Tracy and Katharine Hepburn, plus *The Kid from Texas* with Dennis O'Keefe. Funny men Bud Abbott and Lou Costello, with Patricia Medina providing the glamour, were appearing in the *Foreign Legion* at the Gaumont in The Triangle.

Sporting entertainment in the first week of September was provided by Yeovil Town Football Club beating Dartford 2 – 1 in the Southern League at the Huish Ground on Wednesday evening. On the following Saturday, the town club played Welsh new-comers to the Southern League, Llanelly, to a goal-less draw away at Stebonheath.

Yeovil and District Homing Society sent 26 pigeons 167 miles to Chesterfield, and the first home was Mr H. Helyar's bird.

Yeovil Police Eleven's cricket season ended with a record of played twenty-three, won twelve, lost ten and drawn one. The batting was headed by Chief Inspector Taylor with an average of 26.2 runs, second PC Box with 19.6, and Sergeant Fermor, third with 11.7; Sergeant Fermor topped the bowling averages with 69 wickets at a average of 9.3 runs.

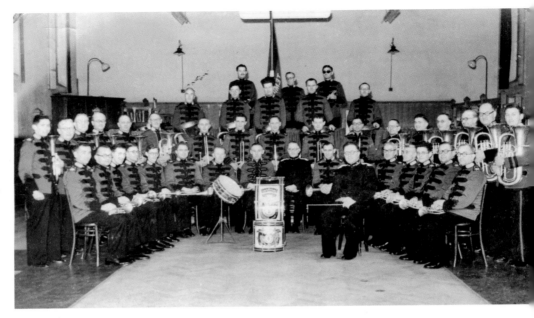

The Yeovil Salvation Army Temple Band, 1950.

Yeovil Amateur Boxing Club was formed at a meeting in Yeovil School on Friday 1 Septembe
Mr Jim Knight, the Area Youth Organiser, stated that two boxing rings, plus punch balls an
boxing gloves, were already available for the new club which would meet weekly on Frida
evenings in the Yeovil School gym. The first members to join were J. Newman, G. Stagg, I
Edmunds, R. Johns and F. Darrell.

The *Western Gazette* reported the Golden Wedding of seventy-four-year-old Mr Harr
Mitchell and his seventy-three-year-old wife Florence, of 41 Eastland Road, who were married i
St Michael and All Angels' Church on 8 September 1900 and who

Have many memories of Yeovil before the turn of the century, and recall that when they were
married and went to live in Eastland Road there were no houses on one side of them at all! One
of Mr. Mitchell's most cherished recollections is of the days when he played football for the old
Yeovil Casuals team at right half. He proudly displayed two treasured cup medals, one for the
season 1895-96, when he helped to win the Somerset Junior Knock-out Cup, and the other for
the following season, when the Yeovil team were placed at the top of the Somerset Senior League.
He played for about five years. Mr. Mitchell, has for the greater part of his life, been employed in
the gloving industry. Until the time of his retirement in 1947, he was a leather staker at the firm of
Messrs. Blake & Co., Reckleford, having 42 years service with the firm. Previous to that he was with
Messrs. Raymond Bros., now the Goldcroft Glove Co. Both Mr. and Mrs Mitchell enjoy excellent
health, Mr. Mitchell having spent only a fortnight in his whole life in bed on account of sickness.

On Saturday 2 September, a party of Yeovil Salvationist travelled down to Poole and gave
musical programme. The party included Bandmaster T. Attiwell, accompanied by Bandsme
G. Askew, R. Hilborne, Derek Lush, D. Martin and E. Stannard.

October

A Yeovil High School for Girls' tennis team, *c.* 1920.

Young pupils of Huish Infants School in 1935.

October, 1874

Looking through my copy of *The Illustrated History of the 19th Century – Month by Month
– Year by Year*, I read that in 1874 an English surgeon, Abraham Groves established the practice
of wearing sterile rubber gloves when operating, and by pre-sterilising his surgical instruments
thereby dramatically reducing post-operative death rates from infection. In the USA, Joseph
F. Gliddon patented his invention of barbed wire, and the inventor of denim jeans, Levi Strauss
introduced a new range with copper rivets at the points where there was the greatest wear and
tear. In October 1874, Great Britain annexed Fiji.

The 'popular entertaining lecturer' Mr George Grossmith, failed to attract a large audience at
his lecture on 'Social Bores' in the hall of the Mutual Improvement Society. The *Gazette* reported
that the subject was especially suited to Mr Grossmith whose 'face is one which provokes a laugh
even before he utters a word. One sees the merry twinkle of his eye, that he is brimful of fun and
funny stories, and before he has spoken two minutes, his audience is tittering audibly.'

Yeovil's season of entertainment continued during the first and second weeks of October 1874
with the Royal Princesses Comedy and Burlesque Company's entertainments in the Town Hall
beginning on Friday with 'Links of Love or Blighted Vows' and 'The Model Woman'; Saturday
'Lady Audley's Secret' and 'The Spectre Bridegroom'; Monday 'Good as Gold' and 'Little Black
eyed Susan'; Tuesday 'Faust and Marguerite' and 'Two in a Fix'; concluding on Wednesday with
'Tried and True' and 'Mistaken Identity, or in the Wrong Box'.

However, providing entertainment in liquid form landed George Vickery, of the Wellington Inn
Wellington Street, before the first October sitting of the town magistrates, summoned for keeping
his pub open for the sale of beer at unlawful hours on Sunday 6 September. PC Saunders told the
Bench that he had found three men at the back door of the inn with 'a quart of half and half'. George
Vickery was fined £1 with 17 shillings costs and his licence endorsed, this being his second offence.

The *Western Gazette* cautioned its readers with the following report on 2 October.

> An old lady living in Rustywell had a narrow escape at the South Western Railway Station a few
> days ago. She was shaking hands with a friend while the train, by which the latter was leaving,
> was in motion and slipped down on the platform, close to the carriages. Fortunately help was
> at hand and she was prevented from falling beneath the wheels; otherwise she would probably
> been crushed to death. Moral: Friends should do their hand shaking before the train moves.

The local 16th Somerset Rifle Volunteers held their annual dinner and presentation of prizes in
Newton House on 8 October. At 3 o'clock the eighty-five Volunteers paraded and marched to
Newton Park where they

> Engaged in a "sham fight", the plan of which was an attack and defence of Newton House.
> Captain H. E. Harbin took charge of the defending party, and the "invaders" were led by Sub-
> Lieut. Marsh. Twelve rounds per man of blank ammunition were gallantly expended, and the
> combatants then fraternised and together they entered the "squire's" hospitable mansion where
> a really sumptuous dinner awaited them.

And finally, in the event of a member of the Volunteers damaging a tooth in the 'sham fight', Mr
Webb, Surgeon Dentist attended every Friday at Mrs Griffin's, Princes Street, where he could be

Newton House was 'attacked' and 'defended' by the Rifle Volunteers.

NEWTON HOUSE.

Consulted FREE OF CHARGE on the patented and painless improvements of Dentistry and inspection of specimens invited, teeth extracted painlessly by the use of Ether Spray and Nitrous Oxide or Laughing Gas.'

A Letter Home from the Front

During the First World War, letters home from soldiers and sailors serving on the various Fronts were often published in local newspapers and, in many instances, the matter of fact tone of the letters belied the true horror of the events described.

The campaign, which took place from 1915-18 during the First World War in Macedonia and around the strategically important Greek sea port of Salonika (now Thessaloniki), was considered by many to be a 'side-show' to the Western Front, but to those who took part it was principally remembered for the appalling weather, extremes of temperature and disease, the most feared of which was malaria. Out of nearly half a million Allied casualties at least 450,000 were invalided out of theatre suffering from malaria, which for many was fatal, and for others would recur during the rest of their lives.

In March 1916, Rifleman Martin, serving in Salonika with the 4th Battalion, The Rifle Brigade, wrote home to his parents in Sparrow Road, Yeovil telling them something of the conditions he was experiencing.

Try to picture a hole dug in the ground, half way down a steep and rocky hill, about 2 ft. deep and 6ft. square, covered with our rainproof (?) sheets; also decorated with shrubs and branches of trees to disguise it from the enemy aeroplanes and you have our "house" where four of us contentedly dwell. It was about dinner time when the rain and hail came in torrents, accompanied by vivid flashes of lightning and thunder galore. It had been raining about half-an-hour when suddenly it poured through the small gap where two of our bivouac sheets are

Guerre 1914-1915 — 22 - *La Chapelle de après les premiers combats du mois de Mai.*

Edit. Ledien, 36, rue de l'Echiquier, Paris

A censored postcard sent home from an unknown location on the Western Front in August 1915.

joined and in no time we were almost floating on the water. When it had moderated a little we went outside and put our waterproof capes over the lot, so after that we defied the rain, hail and anything else. Having seen to the outside we had to work inside and were kept busy for some time bailing out the water then scraping the floor level, and drying it as much as possible after which we got some dry bits of heather and put down on the floor, so that kept some of the dampness from us. Our blankets and coats were rather wet, however, so you can guess we had a very "bon" night. It was just about dusk when we were able to get things "home-like" and comfortable, when we heard the wonderful cry "Turn out for the mail!" Well we had quite a good fat mail bag this time, and we quite forgot our recent trials, and had a good feed

I believe Rifleman Martin survived the war but I don't know whether he suffered from malaria.

A Review and a Pantomime

For two nights on Friday and Saturday 6 and 7 October 1950, the Wessex Social and Sports Club presented their first review 'Southern Lights' to full houses in St Joseph's Hall, Reckleford, with items ranging from quick fire cross-talk to straight songs and from dramatic monologues to hand bell ringing. The *Western Gazette* reported that:

> There was a commendable degree of freshness about the show and the fact that the members of the company looked as though they were enjoying themselves proved contagious.
>
> The short sketches moved at a good pace while the choice of songs, particularly "If I love you" from the new American musical "Carousel" went down well with the audiences.
>
> Originality was well represented by the condemned-cell monologue, "Confession" written by a member of the cast, while the first half of the programme was rounded off on an hilarious note with a musical "recital" by the Philharmaniacs - a band of unmusical gentlemen who produced melody in the Spike Jones manner.

The show was produced and compered by Mr. Bill Consitt, Marjorie Austin and Hilda Carter were at the two pianos, while Roy Grant played the violin, as well as a speciality turn on the saw.

The company comprised Gladys Miller, Eileen Matthews, Frances Hodges, Delores Carter, Mary Friend, Maureen Giles, Maureen Mullaney, Pat Johns, Bert Hill, Don Spinner, Cyril Auton, Ken Dover, Ted Hallett, Michael Budden, Bert Jennings, Ron Pilkington, Doug Smith, Val Johns, Arthur Johns, Mick Stanley, Wilf Fishburn and Roy Grant.

A few years later on Tuesday 22 February 1955, the ever popular Wessex Social and Sports Club presented its eighth annual pantomime in the Princes Theatre. The eleven-day run proved a popular choice and one of the Club's best productions.

Under the headline 'Yeovil Production Has Zest and Pace' the *Western Gazette* wrote:

"CINDERELLA," the fairy story which captures every child's heart, is probably the best-loved of all pantomime subjects and it is proving a popular choice for the Wessex Social and Sports Club's 1955 production at Yeovil. It had its first night on Tuesday and will have an 11-day run.

This is the club's eighth annual pantomime and should prove one of the best to date. It is unfortunate that the show is forced to make such a belated appearance in the town at a time when the spirit of Christmas is fast receding into the dim past.

Doreen Campbell is a subdued but winsome and appealing Cinderella. Her voice is sweet yet it has little volume and needs to be amplified more. Opposite her as Prince Charming is Dolores Carter, in what is possibly her best pantomime performance. She has a good stage manner and is equally at ease whether speaking a line or singing a note.

The cast of 'Southern Lights'.

Noel Gulliver brings the right amount of comic pathos to the role of Buttons. This diminutive comedian never wastes a line and his timing is sound. And, of course, the humour is well looked after by the contrasting ugly sisters, played by Geoff Failes and Ted Hallett.

Dandini is capably portrayed by Valerie Stead, who is one of the big successes of the show. Trim and gay, she is especially impressive in the dancing sequences.

After shedding her long black cloak Isla Lydford reveals herself as a youthful and charming Fairy Godmother.

The well-discipled chorus comprises Jean Campbell, Deanna Chant, Avril Cook, Julie Eyres, Josie Holmshaw, Pat Johnson, Heather Lucas, Helen Scammel, Maureen Smith, Judy Tregear, Marjorie Turner, Mary Watkins and Dorothy Wood.

The Nestlé Milk Factory

The year 1897 was a busy one for Yeovil Borough Council, and a number of its decisions would change the face of the town during the coming century.

A new town water supply reservoir was approved for the top of Summerhouse Hill and work began that year; licences were granted to Messrs Maynard & Son and Messrs Aplin and Barret for a bacon and sausage factory in Newton Road and from which would be produced the famou St Ivel brand of cheese and dairy products; plans were approved for a large glove factory fo Messrs Raymond & Sons in Goldcroft; and the gift of land in Ram Park was accepted and on which Sidney Gardens would be laid out. At the last meeting of 1897, Mr Petter's offer of a band stand for Sidney Gardens was accepted and the thatched timber building would be a prominen feature of the Gardens for nearly seventy-five years until it was burnt down by vandals in 1972.

However, it is interesting to speculate how Yeovil might have developed if the Borough Counci could have guaranteed a water supply back in 1897.

At the October meeting the Mayor told members that Messrs Nestlé wished to establish a branch of their condensed milk business in the town provided the Council could guarantee a sufficient supply of water. Preliminary discussions had been held with Mr Henri Nestlé, and his company had been assured that in the event of the factory being built in Yeovil, the Counci would use every effort to meet their requirements providing they knew what they were.

In reply Messrs Nestlé asked if the Council could guarantee an unfailing supply of 600 gallon of water per minute daily for a period of between eight and ten hours. They also enquired i the Council could guarantee that in one or two years time the factory could be supplied with 1,000 gallons of water daily for the same number of hours, and if so, at what price. The Counci was also asked to guarantee that if there was a drought, the supply to the factory would be maintained, even if the town suffered a water shortage. Unless these guarantees could be given there was no way in which the factory would be located in Yeovil. Unfortunately the Borough Council, who had suffered a water crisis for many years, and indeed would continue to do so until well into the twentieth century, could not give this guarantee.

There was, however, a last ditch attempt not to lose what was seen to be a very importan addition to the economic life of the town. Mr H. B. Batten, the Town Clerk, wrote to Messrs Nestl advising that the Aldon Estate, which belonged to his father, adjoined the railway line for some distance between Hendford and Yeovil Town Station, and flowing through the land there was a stream which took water from Ninesprings at a rate of about 140 gallons per minute. Mr Batte

This view would have been somewhat different if the Nestlé milk factory had been built.

lso pointed out that his uncle owned a piece of land nearby to the south of Penn Hill, and he had eason to believe that an almost unlimited supply of water could be obtained from this site. He xplained to Messrs Nestlé that the Borough Council had once considered taking water from this pot rather than from the source eventually decided upon many miles from Yeovil. The town clerk vent on to say that his father would be willing to consider disposing of such quantity of land as Messrs Nestlé might require for the factory within this vicinity, and he believed that a daily supply f about 100,000 gallons of water could be guaranteed. However, before proceeding further, the Council would want some confirmation that the company intended to establish itself in the town.

Unfortunately, even though the Mayor and the Town Clerk visited Mr Henri Nestlé in London, his last minute effort did not bear fruit because the company stated that they were not prepared o establish a factory in a town which could only guarantee the essential water supply partly rom its own mains and partly from other sources.

October, 1926

On 8 October 1926, the *Western Gazette* reported that: 'A Victoria Plum tree in Vincent Street s bearing its second crop this season. Ripe plums have been picked from it this week.' This first veek of October also has some importance for me, but more of this later.

Appearing in the magistrates' court on 2 October, a labourer and a bricklayer, both of no xed abode, stood charged with 'failing to do the allocated task as casual inmates of the Yeovil nstitution'. This was formerly called the Workhouse in Preston Road. The *Western Gazette* eported that Mr Thomas Pollard, the Master of the Institution, told the Bench 'that at 8 'clock that morning the two men blankly refused to do their allocated task of cracking stones nd persisted in their attitude after he had appealed to them. One of the men had been very iscourteous. If they were willing to return to do their task he would withdraw the charge.' Both nen said they were unemployed and were on their way from Chard to London to seek work and efused to go back to the Yeovil Institution. The magistrates sent them to prison for fourteen days vith hard labour.

1926 was the year of the General Strike, and reflecting the hardship which many people were experiencing in the difficult economic state of the country, the evening classes at Reckleford Boys' School were offered free to unemployed work people.

There was a large audience for the concert given by the Penybryn Welsh Miners' Choir in the Town Hall on 2 October, and at the end a vote of thanks was given to those townspeople who had provided the choir with free hospitality.

Petter's Cricket Club held their annual invitation dance in the Princes Street Assembly Rooms on 5 October to the music of the Princes Orchestra; the decorations were lent by the Yeovil School Old Boys' Association, and Mr C. Cridge was MC.

The Central Cinema was showing the *Phantom Express* a 'stirring railway drama', the *People versus Nancy Preston* a 'drama of tragedy, laughter and tears,' and *Loyalty* starring Sessue Hayakawa whose 'splendid acting and the undiminished magnificence of his Oriental Personality places the production at the pinnacle of achievement.'

On the football field Yeovil went down 4-0 away the arch rival Weymouth on 6 October. However the *Western Gazette* reported that:

> The "Glovers" gave one of the finest displays seen on the Weymouth ground this season, and only the strong defence and brilliant goal keeping by the Weymouth custodian prevented them from scoring. On the other hand the Yeovil backs were very weak, and it was their failure to clear effectively that resulted in the team's downfall. The rearguard wants strengthening quickly.

St John's Church was filled to overflowing at the Harvest Thanksgiving Evensong of Sunday 3 October. The *Gazette* reported that

> A queue had begun to form quite early and when the service commenced the church was filled in every part, seats being placed in the aisles as well as under the belfry tower, in spite of which a great number of would-be worshippers were unable to find accommodation. The church had been tastefully decorated with fruits of the earth by the ladies of the congregation.

And why was this first week of October 1926 of some importance to me? Well on 7 October my parents Reginald Sweet and Edna Swetman were married in St John's Church and remained happily together for the next sixty-three years.

Approaching Yeovil from Babylon Hill in 1926.

November

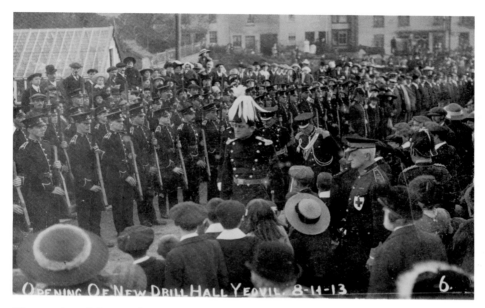

The opening of the new Somerset Territorial Army Drill Hall at Southville on 8 November 1913. In August 1914, at the outbreak of the First World War, many of the Territorials on parade would be on active service in France.

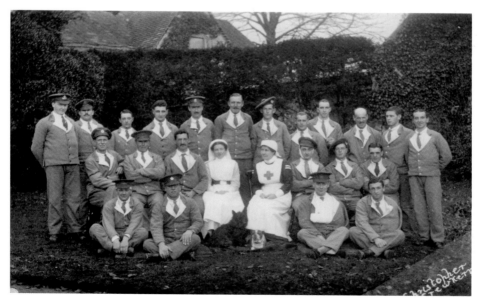

Wounded soldiers from the Western Front recovering in the Red Cross Hospital at Norton Manor, Norton-sub-Hamdon.

November, 1903

Yeovil's Guy Fawkes Night, on 5 November 1903, passed quietly – 'The only demonstratio
being the discharge of fireworks &c., by the juveniles'. However, some of the 'juveniles' went
bit too far, and ended up before the town magistrates for letting off fireworks before the 5th. O
3 November, Sidney Boon, Victor Smith and Frederick Norris, described as 'lads' were each fine
one shilling for letting off fireworks in Kingston in the sight of PC Barber, who happened to b
on duty in plain clothes. Also before the Bench were 'small boys' Bert Pennell, Claude Webb an
Bertie Stevens, charged with letting off fireworks in the sight PC Casey. However Bert Penne
said that he didn't have any fireworks, only a Roman Candle, but PC Casey told the Bench th.
the boys 'had fireworks which exploded with a loud bang'. All three were found guilty and fine
one shilling each.

 Reports of local court cases in past columns of local newspapers, not only give us a glimps
of how people lived but also how they worked. In 1903, an inmate of the Workhouse could b
brought before the magistrates charged with refusing to work. On 5 November, a male inma
from the Yeovil Union Workhouse in Preston Road appeared before the Bench who were told b
the workhouse Master that he had given the man a quantity of oakum to pick but this had bee
refused. (Picking oakum was a classic workhouse task which involved picking and pulling ou
old rope into loose fibres, which then were tarred and used to caulk or repair leaks in woode

The Yeovil Union Workhouse on Preston Road where an inmate refused to work.

hips) The Medical Officer of Health had certified that the man was fit to do this work and the Master explained that he had brought the inmate before the Bench so that he would understand the workhouse regulations had to be obeyed. The Master stated that he had tried to get the man to work but without success. In his defence, the man said that he was willing to do any other work but not to pick oakum – 'which had been put upon him as a punishment because he spoke the truth'. The chairman of the Bench told the man that he must obey the regulations and he was sent back to the workhouse.

In the afternoon of 3 November, young George Hann, of Victoria Road, was running across the Pen Mill School playground, carrying a boy on his shoulders, and the inevitable happened, but with dire results. George collided with another boy and as a result George suffered a broken thigh. Following first aid at the scene, the youngster was carried home by his father and Mr Payne, the Headmaster, and where his injuries were 'surgically attended'. The report does not say whether George was eventually taken to hospital but if so, he would have featured in the November statistics.

In 1903, it was unlikely anyone would raise an eyebrow at the idea of the local Lodge of the Manchester Unity of Oddfellows holding a 'Smoking Concert' in the Half Moon Hotel in Silver Street (Marks & Spencer's store now stands on the site). Before the concert began, Mr C. W. Mead of East Coker, was presented with the emblem of a Past Provisional Grand Master for the office he had held for twenty-four years; this was the first time the emblem had been presented in public.

On 2 November, the annual town council elections were held to fill the vacancies of the four retiring members in 1903. Voting took place at the four town polling stations, and 1704 electors out of 2,361 cast their votes. At 9 p.m. and in the rain, a large crowd assembled outside the town hall in High Street and cheered the announcements of the results.

Sadly on 4 November, Mr Joseph Thorne, of Hill View, passed away, aged 56 years, he was the first president of the Yeovil's Glovers' Union.

Boots Rises from the Ashes

On the night of Good Friday, 11/12 April 1941, the Medical Hall, which had stood at the corner of Middle Street and the Borough for over a century, was destroyed by a German bomb in the sixth enemy air raid on the town. Boots Chemist owned the building at the time and relocated their business to other premises in Middle Street, pending the opportunity to rebuild their shop. Following the end of the Second World War in 1945 and the restrictions in rebuilding which followed, the bombed site was turned into an ornamental garden, and so it remained until 1956 when Boots finally received the go-ahead to build a new shop.

On 30 November 1956 Boots opened their new shop, over fifteen years from the destruction of the old Medical Hall. The *Western Gazette* reported that:

With the opening today of Boots' new shop in Yeovil, an open space that has existed since an air raid in 1941, has finally been developed.

That the return to their old site has been so long delayed is not the fault of the Company. The real reason was that in the immediate post-war years it was necessary to concentrate building efforts in the very heavily-bombed cities of Portsmouth, Plymouth, Swansea and other

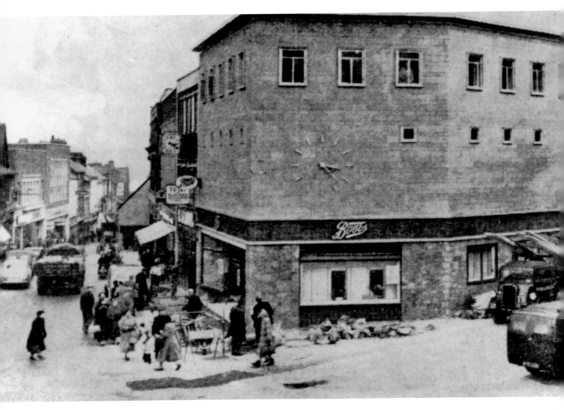

The new Boots Chemist shop nearing completion.

places where the need was obviously much greater. Thus in spite of the most strenuous efforts both by the Company and by the Town Council, licence applications had to be continually refused.

In the building of the new shop no attempt has been made to produce a replica of the original premises. Such a course would it is stated, have been impractical in any case, because part of the site had to be given up for the widening of Wine Street and the Borough. Nevertheless, whilst contemporary ideas have been embodied in the new structure, it is claimed that care has been taken to harmonise the building with the character of the town, and in this connection a point of special interest is that local Ham stone has been used for most of the facade.

The total cost of the building, fittings and stock has been in the region of £90,000.

The whole of the ground floor is devoted to the main pharmacy departments - chemist, surgical and toilet - and to farms and gardens and photographic supplies. The fittings are of the most up-to-date pattern and each department is clearly marked by illuminated signs in the cornice band above the wall cases.

The first floor houses the gift departments, and there is a wide curved staircase to give easy access for the public.

The second floor carries stock-rooms for the first floor sales area and also contains the staff accommodation. The staff tea-room overlooking Middle Street and the Borough is extremely

light and airy, decorated and furnished in contemporary fashion. There is also a kitchen to provide snacks and light meals.

In the cloakroom each girl has her own locker for small items, while her coat and outdoor shoes are accommodated immediately below. Ample powder tables and mirrors are also provided. Every endeavour has been made in the selection of fittings, colour schemes and furnishings to provide attractive and restful quarters for the staff when off duty.

It will clearly be seen that a lot of time, thought and money has been expended on this, the newest of the firm's branches, and it is claimed that the finished shop is a credit, not only to Boots, but to the town of Yeovil as well.

tories from the War Memorial

he Yeovil War Memorial in the Borough contains 355 names: 236 men from Yeovil who died in e First World War from 1914 to 1919; 76 servicemen and 42 civilians who lost their lives in the cond, 1939 to 1945.

At this time of annual remembrance of the fallen, and to ensure that we never forget their crifice, I am telling you the stories behind a few of these names taken from the War Memorial egister I compiled in 2005.

Private Henry Hockey of the 32 Battalion of the Machine Gun Corps was killed in action France on 9 November 1918, two days before the Armistice brought the ceasefire along the 'estern Front; he had been called up on 11 April 1918, and had only served one month in the ont line. Henry, whose parents were living at Pen Field, Sherborne Road, was twenty-four years d and had been married five months. In a letter to his wife, who was living with her parents--law, Henry's commanding officer stated that he had been killed instantly with several of his mrades by a mine explosion. Before joining the Army, Henry had been employed as a clerk by e Phoenix Engineering Company at Chard, and was a keen footballer.

Seventeen-year-old Private Walter Adams of the Royal Marine Light Infantry was lost in the nking of HMS *Hampshire*, off the Orkneys on 5 June 1916, and in the *Western Gazette* of the June it was reported that:

He was the son of Mrs. L. Moseley (by her first husband) and grandson of Mr. W. Bond, of 32 Crofton Avenue. Before joining the forces, he was employed at the "Western Gazette" Offices, and was connected with the Sports Club, being a good runner, footballer and swimmer. On Wednesday morning a postcard was received from him saying that he had come through the great battle [Jutland] quite safe, and would write a long letter later.

the following September the *Gazette* would report that Walter's body had been recovered and ried in the Naval Cemetery at Lyness in the Orkneys.

Air Mechanic 2nd Class, Maurice Poole, Royal Air Force, whose parents lived at 21 Orchard reet, died from double pneumonia at Aboukir, Egypt on 25 June 1919. Aged 18, he had been in e RAF only 12 months, 11 of which he had spent in Egypt. In a letter sent on 17 June, Maurice rote that he was well and hoped to return home shortly. This was the second blow felt by Mr d Mrs Poole who had lost their elder son William from enteric fever at Basra Hopsital on 14 ptember 1918 aged 20; he was serving with the Northuberland Fusiliers.

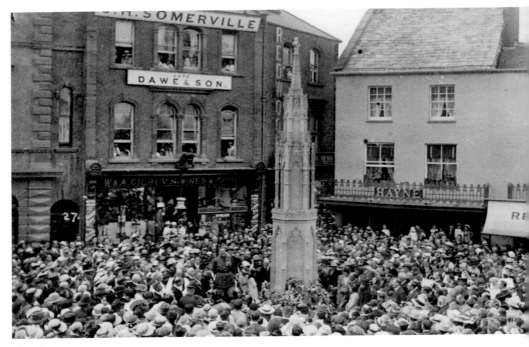

The dedication of the War Memorial on 14 July 1921.

Petty Officer John Perry was a member of the crew of HMS *River Tyne*, a block ship sent t
block the harbour of Dieppe as the German Army swept west during the invasion of France
June 1940. The ship had been previously a merchant steamer named SS *River Tyne* and wa
acquired by the Admiralty following mine damage. Petty Officer Perry died when the ship wa
sunk by a mine off Dieppe Harbour on 10 June 1940 but His Majesty's Ships *Kauo* and *Jacobu*
the two other block ships which had sailed with *River Tyne*, were successfully sunk in th
approach channel to the port. John Perry had served for twenty-three years in the Royal Nav
and on returning to civil life, had worked at Westlands before being recalled to service in Augu
1939; he left a widow and two children living at Westland Road.

Corporal Bernard Nowell, Royal Air Force, was a crewman on board a Walrus amphibiou
seaplane of 10 Squadron, Royal Australian Air Force, which left RAF Mount Batten, Plymout
at 03:00 hours on 18 June 1940, and crashed at Ploudaniel, a village some 21 kilometres nort
east of Brest. All four occupants of the aircraft were killed – the Pilot Flt Lt J. N. Bell, RAA
Air Observer Sgt C. W. Harris, RAAF, Crewman Cpl Nowell RAF, and Captain N. E. Hop
Intelligence Corps, attached to Section D of the Secret Intelligence Service (MI6). The party wa
on a top secret mission on the direct orders of the Prime Minister, Mr Winston Churchill,
rescue the wife and daughter of General Charles DeGaulle, from the rapidly advancing Germa
Army. The Walrus was heading for Carantec on the Brittany coast but crashed near Ploudanie
The cause was never properly established, but two possible reasons were put forward. On
report stated that a radio transmission from the aircraft indicated that it was being attacked b
enemy fighters, and the second reported by villagers, was that the Walrus was brought down b
a German anti-aircraft battery at Valeury as it crossed the coast. Whatever the cause, the aircra

as some 35 kilometres off course; General DeGaulle's family would escape on one of the last ships to leave the harbour of Brest later the same day.

Gunner Leonard Jukes of 241 Battery, 77 Heavy Anti-Aircraft Regiment, Royal Artillery, was captured by the Japanese in March 1942 but died of dysentery and beriberi in Ambonia - one of the islands of the Moluccas - on 12 January 1944. Leonard, whose parents lived at 58 Victoria Road, was aged twenty-three and had worked for the printers, Messers Stevens & Co. Although Mr and Mrs Jukes were notified in July 1943 that their son had been captured, his death was not confirmed by the War Office until November 1945.

Mrs Lily Hoyle and her five-year-old son, Trevor, were killed when their home at 23 Westland Terrace, was completely destroyed by an high explosive bomb during the fifth German air raid on Yeovil on 26 March 1941. The remains of Mrs Hoyle were found in the debris of the house, but those of little Trevor, who was known to have been in the house at the time, were never found.

November, 1932

During evening of the 3 November 1932, the Yeovil Guy Fawkes Carnival procession wound its way through the town centre and was described by the *Western Gazette* as 'A long cavalcade of colour and gaiety which filled the streets with a dense crowd of spectators.' Nineteen-year-old Miss Mildred Pope, the Carnival Queen, her attendants, and the 80 strong Pyjama Guard, took pride of place in the procession of tableaux, comic turns and scores of walking entries accompanied by four bands, which entertained the town during that crisp late autumn evening. The carnival was organised by the Red Cross Somerset Voluntary Aid (VAD) Detatchment/19 in aid of the Ambulance Fund because in 1932 the Detachment provided and maintained the Yeovil Ambulance service.

While on the subject of local health, Yeovilians were being extolled by the Town Council's Public Health Department to make a special effort during the forthcoming Rat Week, beginning on 7 November, to kill as many rats and mice as possible, because 'rats and mice destroy food and materials and are a source of danger to the community'. Townsfolk were informed that rat poison could be obtained at all chemists, and dogs and ferrets could be usually employed to destroy these pests.

At the Town Council meeting on 9 November, Alderman A. H. J. Stroud, described by the *Gazette* as Yeovil's first 'working-man' Mayor, was formally elected to the office of first citizen, and was handed the ceremonial mace by the retiring Mayor, Alderman William Earle Tucker. In accepting the great honour, the new Mayor, stated that one of his main tasks for the year ahead was 'To use all the powers the Council possessed in trying to find work for as many unemployed men as possible, and in trying to relieve distress in every way it could.'

Over 250 members of the Yeovil Baptist Church Junior Fellowship, held a 'Mock Lord Mayor's Banquet' in the town hall on 7 November and the *Western Gazette* reported that:

Under the direction of the Ladies' Catering Committee the hall and tables were tastefully decorated for the occasion, and as far as possible strict ceremonial was observed. Distinguished "guests" were announced to a fanfare of trumpets by uniformed trumpeters. During the banquet selections were played on a radiogram, lent by Mr. H. J. Singleton, and between the toasts, the guests greatly enjoyed songs by Miss E. Fox, and recitations in dialect by Mr. E. G. Yeates.

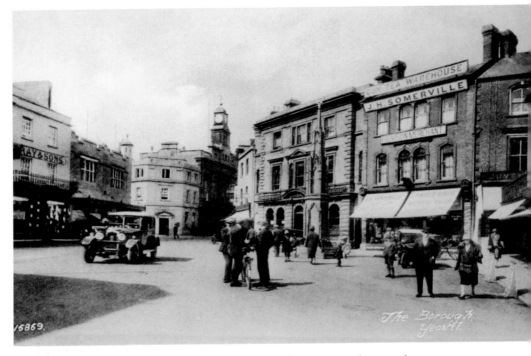

The Borough in the early 1930s where pedestrians still appear to take precedent over cars.

Looking down through the columns of the *Gazette* for those early weeks of November 1932, I read that 120 people attended the VAD Novelty Dance in the Town Hall, and the Holy Trinity Bazaar Dance in the Town Hall was a great success. There were weekly whist drives in the Conservative, Labour and Liberal Clubs, the Ladies' section of the Yeovil Golf Club held a bridge drive in the Manor Hotel, the Pen Mill Methodist Sunday School held an Autumn Festival and there was a concert in the Pen Mill Methodist Sunday School room in aid of the 3rd Yeovil Company of the Boys' Brigade. The St Michael's Women's Dramatic Section gave a concert of songs, recitations and comic sketches in aid of the Bazaar Fund, and some thirty senior members of the St Michael and All Angels' Church choir and servers enjoyed their annual supper in the church hall presided over by the Vicar, the Revd Stephen Purcell. The local Labour Party's concert in the Unitarian hall was presented by the 'Klinkers' Concert Party – the 'Klinkers' who were well-known and popular in the area, were Miss Gladys Ostler, Miss Winifred Seabright and Messrs W. Connelly, L. Child, G. and L. Pittard, and L. Sibley at the piano.

December

Two streets which have changed little since these photographs were taken over a hundred years ago.

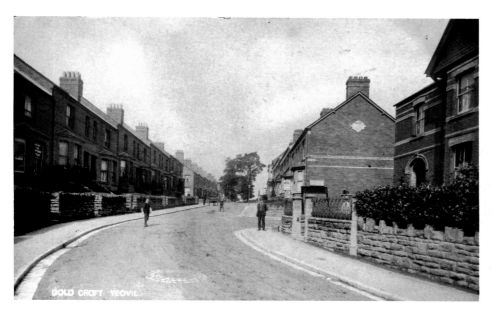

Goldcroft.

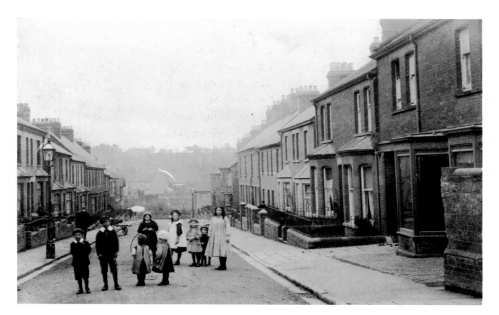

Orchard Street.

December, 1900

Reading through the columns of the *Western Gazette* for early December 1900, there seems to have been a catalogue of accidents and alarms reported, not only locally, but nationally as well. With Christmas and its festivities not too far away, the following report may have sent shivers down the spines of some supporters of our local hostelries.

'POISONED BEER'

As a result of the analysis of beer at Chester, four samples of beer were found to pure, but four others were found to contain arsenic. It is stated that about 800 barrels of beer brewed in Chester have been destroyed. The local Health Committee has issued a warning that "As the sale of beer so contaminated is a serious offence, every brewer and retailer should satisfy himself of the purity of his beer. Samples will be taken for analysis without further warning."

Though no fatal cases of alleged poisoning by beer are reported at the Liverpool Hospitals, large number of patients are under treatment for neuritis. To avert mischief, 1100 barrels of suspected beer have been turned into the sewers.'

Dr. Tubb Thomas, the county medical officer for Wiltshire, is taking similar steps in the area under his charge, and the Country Brewers' Society are also taking all necessary steps.

John Sims was driving a Bradford & Sons' wagon with a load of lime and bags of coal up Sherborne Road, but in trying to stop one of the bags from falling off, he lost his balance and fell off himself. One of the wagon's wheels passed over John's right wrist, and he was taken to the District Hospital for treatment; he also suffered a severe scalp wound.

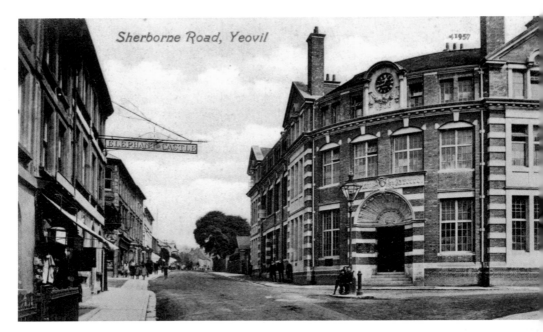

A large hand cart collided with a horse and trap at the junction of Wyndham Street and Sherborne Road.

Sherborne Road was also the scene of an accident at about 6 p.m. on Thursday, 6 December, involving a Mr Peake Mason, who, accompanied by his game keeper, was driving up the road in his horse and trap. Three young lads, named Albert Cook, George Taylor and Morris Chainey, employed by the gloving firm of Messrs Raymond & Sons, Goldcroft, emerged from Wyndham Street pushing large hand cart full of gloves and collided with Mr Peake Mason's conveyance. The impact was severe, Mr Peake Mason fell out of the trap, but his game keeper held on, the shafts of the vehicle were smashed, the horse received cut legs, and Albert Cook who was riding in the hand cart, was thrown under the horse and suffered a cut forehead; George and Morris were unhurt. The horse was taken to Messrs Aplin & Barrett's stables at their creamery in Newton Road, and Mr Peake Mason, who escaped with a slight shaking, continued on his way in one of the company's conveyances. The *Western Gazette* commenting on the accident wrote:

> There can be no doubt that it is nothing less than marvelous that all three persons should have escaped without injury, but the lesson to be learned by it is – (1) That trucks should have lights: (2) that coming out of side streets into the main thoroughfare great care should be taken, especially at night.

At about nine o'clock on the same evening, a 'young man named Giles' and his lady companion were travelling in their horse and trap along Preston Road, when suddenly the harness became loose, and for some reason the horse bolted galloping furiously towards the town. After a struggle, young Giles managed to slow the frantic horse, and jumping from the trap, ran to grab the animal's head. However, before he could do so, the horse swerved across the road and the trap with its young lady occupant crashed into a ditch near the 'Cedars'. Mercifully, neither young Giles nor his companion, were hurt, and apart from a few minor cuts, neither was the horse.

Mainly about Huish

During December 1865, anger over the condition of the road surface of Huish following the laying of a drain, was filling the columns of the *Western Flying Post*. On Tuesday 12 December, the newspaper wrote that:

> We cannot refrain from calling attention to the present disgraceful state of the road leading through Huish in this town. The excavation necessary for laying a drain, which when completed, will undoubtedly be of great use. But the benefits resulting are in a great measure counteracted by the road having been rendered almost impassable. Some portion of it is literally knee-deep in mud, so much so that on Saturday morning an omnibus sank and remained stationary, and it was found necessary to call in the aid of a number of men and an extra horse to extract it. The state of a public road demands the immediate attention of the authorities, and we venture to hope that the when matter is brought before them, they will take steps for removing the evil.

The same page of the *Western Flying Post* contained a report of the previous day's meeting of the Yeovil Town Council when Councillor Milborne stated that several residents of Huish had asked him to bring the condition of the road the council's attention. He went on to say that the residents complained that they could not pass along the road without 'wading through the mud'.

Residents of Paradise Cottages, shown here prior to their demolition in 1936, would have been forced to endure the muddy conditions of Huish.

The Mayor, Councillor Raymond, told the council that when he had walked along Huish to the Cattle Show on the Fairfield during the previous Saturday he had not even soiled his shoes.

Despite the Mayor's comments, the *Western Flying Post* was soon full of complaining and indignant letters. From 'A HUISHITE' came:

Our good friend and staunch advocate Councillor Milborne deserves the warm and hearty thanks of every inhabitant of this locality. The Town Surveyor stated that he sent a man every morning to clear the place, and added "they" were only waiting for fine weather to raise the road in the hollow when the earth piled up by the side of the road would be removed. The answer to this statement to this very easy. The man *alleged* to be sent every morning only scrapes the mud on to the drain, whence in a short time it runs back on the one-third of the road that remains for the use of vehicles and pedestrians. The mud is *not* removed. As to waiting for fine weather I would ask why was not the earth removed directly the drain was finished and not allowed to lie there to become saturated with water and to cover the rest of the road with a sea of mud. *On the morning of the day of the Cattle Show, or on the previous evening, the Town Surveyor, caused to be laid down over that portion of the top of the drain, over which, the Mayor and Town Councillors, and others, had to pass, a thick coating of ashes and the whole of the road leading*

to the field from the Borough was carefully scraped and brushed. But no ashes were laid down beyond the Exhibition Field. That was a smart move on behalf of the surveyor, and bears out what has be stated that if the Mayor, or one of the council lived out Huish-ward the road would not be allowed to remain in its present disgraceful condition for more than one day.

The complaints rumbled on for a few more weeks and no doubt in due course the road was repaired and the residents satisfied, or were they? When reading the columns of the *Western Gazette* for December 1901 I discovered that letters were still being sent to the Editor complaining of the state of Huish!

Christmas in the 1880s

'Old Yeovilian' writing to the *Western Gazette* from Hampshire in December 1946 recorded his recollections of Christmas in the town in the 1880s:

Sixty years ago I was a Yeovil-born boy of 15, and my recollections of Christmas are much the same for several years. Christmas Eve was always a big time for the country people to "come into town," more especially so if the weather was favourable and it was "A light Christmas." The shops had not such early closing hours as they have today – the grocers were open to between 10 and 11 in some instances, for people were not so urged to shop early as they are today. The same may be said of the drapers and the other shops where Christmas presents were a distinctive feature.

Christmas Eve was also a great time for the licensed houses for raffles and draws for turkeys and other birds and for the "breaking" of Slate Clubs and the division of the year's funds. There was a sort of rivalry in the hope that a Slate Club at one licensed house would have a bigger dividend than one at another, although of course, provision for sick pay was the main reason for the Club's existence. A good dividend would probably mean a smaller amount of sickness, though extent of membership was a factor that counted. I remember my father coming home cheerfully on Christmas Eve carrying a big turkey at his back which he had been fortunate in winning at a raffle which succeeded the "break" of his Slate Club.

Then the shops, particularly the butchers' shops, were always festive in their decorations at Christmas. What glorious displays of English beef, mutton and pork, to say nothing of geese and turkeys, there were at the butchers. In many there was a lemon in the open mouth of the pig! My best remembrances of the meat display concern the butchers' shop of a Mr. Puddan, adjoining Dawe's, (the grocers) in the Borough, near the short cut to the Parish Church and Church-lane. Sides of beef of immense size would hang from specially strengthened supports. There were generally sales and shows of Christmas cattle shortly before the great date and the blue or red prize rosette often figured as a decoration on a side of beef or a carcass of mutton. And the geese and turkeys at what moderate prices! True those were the days of plenty and cheapness. They will probably never return with the advanced standard of living now experienced and promised.

I refer to the great Christian festival of Christmas. I don't think it will be disputed that 60 years ago people attended places of worship in larger numbers than they do today. And Christmas morning generally saw big congregations at the different churches and chapels in Yeovil, father

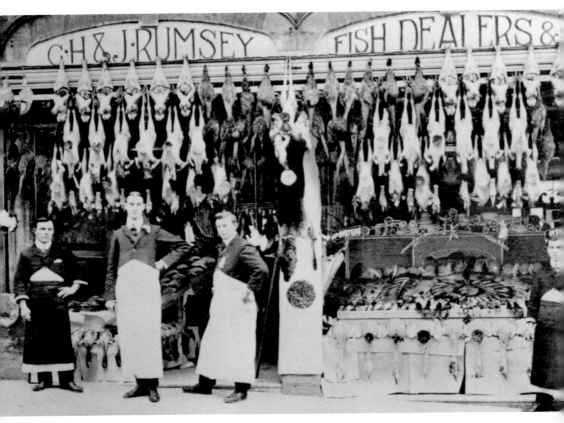

As well as the butchers' displays, Rumsey's fish, poultry and game would have attracted the customers for the festive feast.

and the family attending whilst the good wife cooked the Christmas joint, or superintended the cooking. Heartily and joyously sung were the old favourite hymns, "O come all ye faithful," "Hark, the herald Angels sing," and after church there was a great amount of hand-shaking and good-wishing for "A Happy" or "Merry Christmas." Carols were generally a feature of the services on the succeeding Sunday.

Boxing Day was largely a day for visiting relatives – some families would celebrate Christmas day together and go the son's or daughter's house the following day, and have a proper jollification. If the weather was favourable many people enjoyed a good walk along the roads or across the fields which were so easily accessible before Yeovil so expanded.

At night happiness and hilarity resounded from house to house, more especially in the working class areas and the music of the piano, the fiddle or the concertina was heard to the dancing of the nimble-footed, for there was no wireless in those days.

You know, when I look back to my Christmas's in Yeovil some sixty years ago at the end of the 'Forties' I find myself echoing 'Old Yeovilians' sentiments!!

Christmas, 1952

'YEOVIL-MADE CHRISTMAS PUDDINGS SENT TO NEW YORK' announced the *Western Gazette* in December 1952: 'Three thousand Christmas puddings made in Yeovil will grace the tables of New York homes on Christmas-day. These were a special order dispatched to America by Messrs Aplin & Barrett Ltd.' The *Gazette* went on to report that as goods were becoming more plentiful, shoppers were becoming more discriminating in their spending. The newspaper also reported that although some traders were stating that there had not been the amount of money about against previous years, others told of never better business.

The town's Head Postmaster reported that a new record was established on the last Monday before Christmas, when the franking machines processed 97,000 letters and cards in twenty four hours exceeding the previous highest total by 25,000. He told the *Western Gazette* that co-operation and good temper over Christmas had always been given by townspeople and 'this year the public have definitely assisted us with their patience and good humour'. One hundred temporary staff were employed to cope with the Christmas rush, including 40 senior boys from Yeovil School. In the special department set up in the Newnam Hall in South Street, over 1,000 bags of mail passed in and out daily. The final figure of letters and cards posted in Yeovil between 17 December and Christmas Eve was 508,534, with an estimated similar number coming in.

Shop early was the rule for 1952, and buying appeared to be steady and regular with many people buying gifts 'as far back as October'.

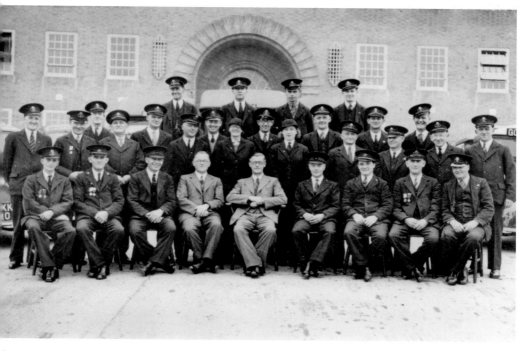

The Head Postmaster of Yeovil and his staff.

For the third year in succession the Yeovil Rotary Club provided the illuminated Christmas tree in Bides Garden, and each evening during Christmas week, carols were sung around the tree by different town choirs and the Salvation Army Band played on Christmas Eve.

In 1952, Houndstone Camp was the 'home' of several thousand soldiers and on Saturday 2 December special trains were laid on at the town station to take over 1,200 servicemen home to the Midlands and the North via London; also coaches were added to scheduled trains leaving Pen Mill to cope with the military demand. Naval personnel from RNAS Yeovilton left on the Tuesday and Christmas Eve. An all-ranks dance and social in the Sergeants' Mess at Houndstone marked the start of the camp's Christmas celebrations and, on Tuesday, 250 children from the married quarters enjoyed a party with presents from Father Christmas. On Christmas morning the Warrant Officers and Sergeants served the 'other ranks' who had stayed behind in camp, with tea in bed and were waiters at their Christmas dinner. The *Western Gazette* reported that no special plans had been made for Christmas at RNAS Yeovilton as only a 'skeleton staff remained' in the base.

Christmas 1952 turned out to be a quiet time with the pubs and cinemas reporting a quiet Boxing night. The Boxing Day football at Huish drew a crowd of 4,000, but only a very small crowd turned out to watch the rugby match at Johnson Park. However the Christmas services in the town's churches and chapels were all well attended and perhaps in contrast to our present festive season, few shops were reported to be open on Saturday 27 December 1952.

At noon on Christmas Day, the electricity supply failed in Barwick, and lasted from between four and eight hours. Many villagers had to delay their Christmas dinners until the evening. The Southern Electricity Board issued a statement of apology stating that the breakdown had been caused by the heavy overloading of the main line transformer resulting in the subsequent shattering of the protective fuse gear.